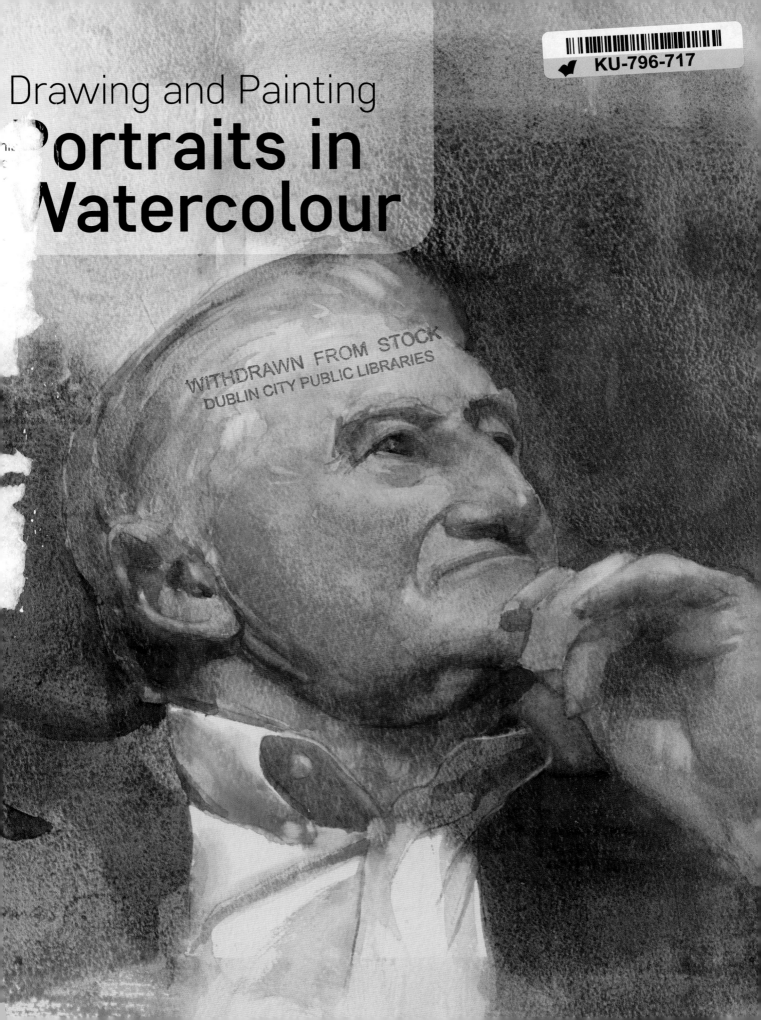

Drawing and Painting
Portraits in Watercolour

Dedication
To Tony Denison, for his friendship, encouragement and wisdom.

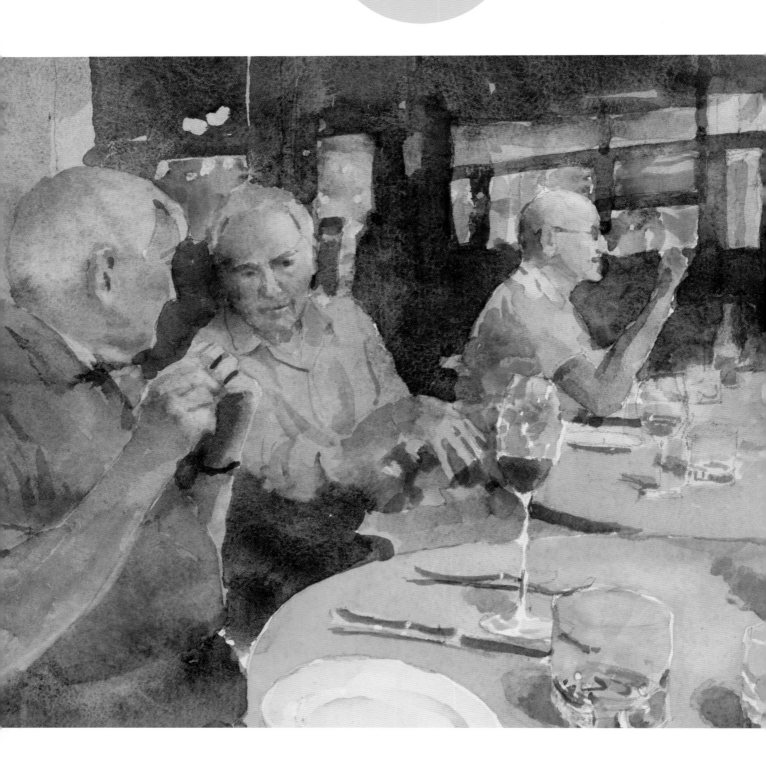

Drawing and Painting
Portraits in Watercolour

David Thomas

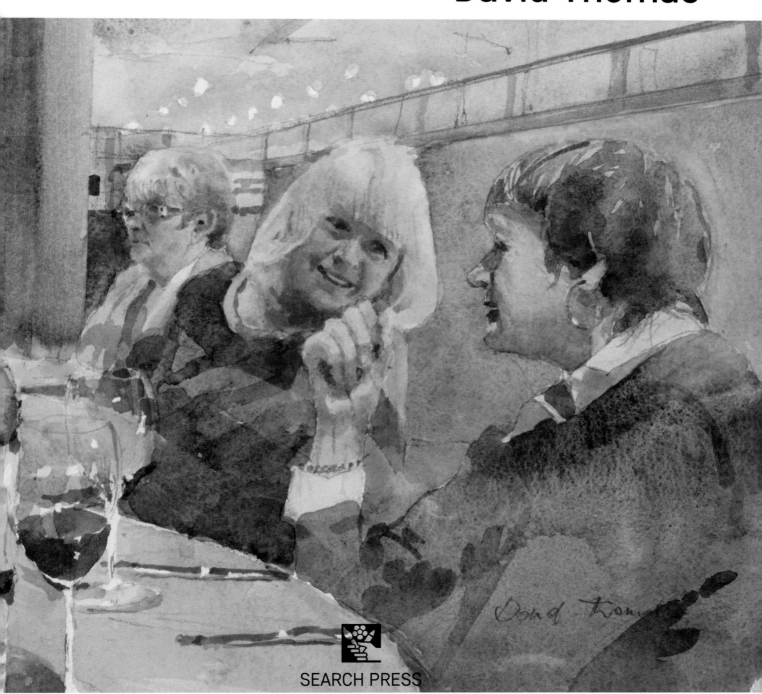

SEARCH PRESS

First published in 2016
Search Press Limited
Wellwood, North Farm Road,
Tunbridge Wells, Kent TN2 3DR

Reprinted 2016

ISBN: 978-1-78221-091-7

Suppliers
For details of suppliers, please visit the Search Press
website: www.searchpress.com.

Publisher's note

All the step-by-step photographs in this book
feature the author, David Thomas, demonstrating
how to draw and paint portraits in watercolour. No
models have been used.

Printed in China.

Page 1:

Morydd

*A Welsh farmer, and my wife's uncle. An energetic piece,
with a varied abstract background. This painting was hung in
the Open Exhibition of the Royal Society of Portrait Painters
and featured in the Royal Birmingham Society of Artists'
portrait exhibition 2015.*

Pages 2–3:

Group Reunion

*This group portrait shows a meeting of ladies, who first met
as student teachers, with their husbands. My wife Beryl is at
the right.*

Opposite:

Siri

*An elegant lady, seen as a guest at a friend's seventieth
birthday party. Her aristocratic demeanour made her a
perfect portrait subject.*

Contents

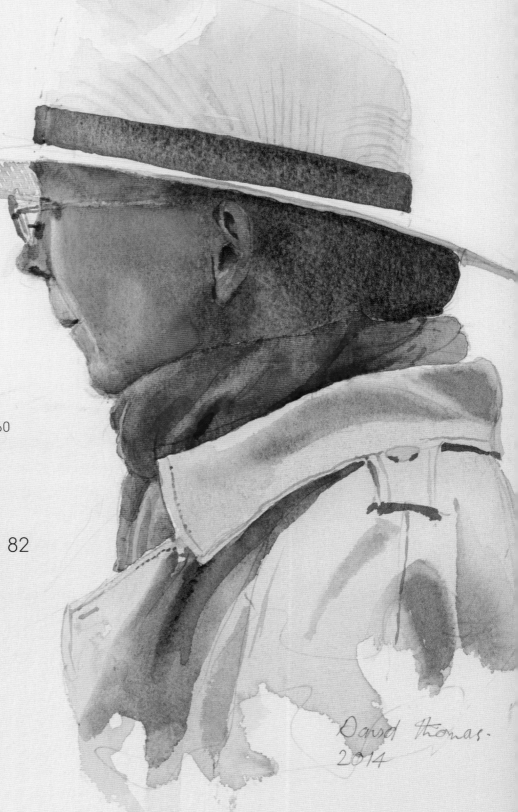

David Thomas.
2014

Introduction

I discovered early an ability to draw. Perhaps it is stating the obvious, but painting portraits places great demands on this accomplishment. Failing to achieve a reasonable likeness will endear you neither to the sitter, nor their friends and admirers. I used to believe that, given plenty of practice, anyone could learn this skill – and although I still feel this to be true, I have come to realise that drawing presents great difficulty to many. Fortunately the human head conforms to consistent general proportions. Being aware of these, and how they are affected by the angle of the head, will help avoid many potential errors, but persistence and hard observation are your main weapons. Although nothing is certain (I once had to change the faces of three siblings from serious to smiling) the reward for your efforts will be in the eyes of your grateful sitter.

There is a great tradition of outstanding watercolour painters, but portrait exhibitions are dominated by oils, and it is quite rare to find examples that do not employ an opaque medium. This undervaluing of watercolour is particularly baffling for us as portrait painters because the medium has an inherent ability to capture subtle tonal variations, which make it ideal for catching those same subtleties we see in every human face. Controlling this tricky medium is the challenge, but an enjoyable one.

In this book it is my hope that you will find examples of sound drawing and a bold but controlled application of colour, and that these will encourage you to persist and improve in your own portrait painting.

Louise
Plenty of space has been left for the model to gaze into. The free brushwork at the bottom of the painting and the darker tones to the right provide an L-shaped area which keeps the attention on the face.

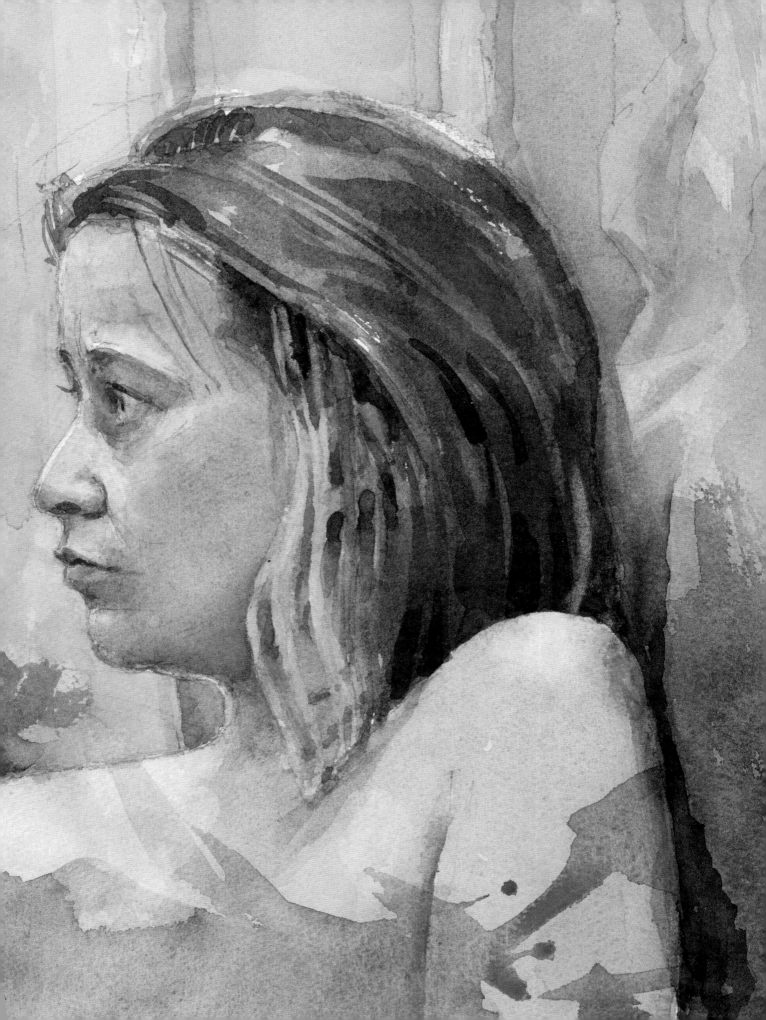

Materials

In general, it pays to use the best materials you can afford. The paints, brushes and paper described here are those I use now, though they have changed over the years. Like many beginners, I set out using watercolour paint in pans, cheap brushes and cartridge paper, working on the kitchen table. However, I quickly learnt the value of better materials.

Watercolour paints

These come in two qualities. Students' quality, whether in pans or tubes, does not have the richness of artists' quality pigment. Artists' quality paint is rich in pigment, but more expensive accordingly. However the difference in effect is worth the money.

Whatever the quality, watercolour paints are available in two types – pans and tubes. Pans are hard blocks of dry colour that need to be wetted. As a result, it is difficult to quickly extract colour from pans. In contrast, tubes have moist contents which can be squeezed out onto a palette and easily picked up by the brush.

Tubes are generally marketed in two sizes – 14ml and 37ml. After a while I realised I was painting enough to justify buying the larger size, which was also more economical. At that time one of the few companies supplying the larger tubes was Da Vinci. I have stayed more or less faithful to them ever since, though now other manufacturers such as Winsor & Newton are also dealing in 37ml.

There are many reputable companies that between them produce a bewildering array of colours. Later in the book (see page 70) I describe my own palette of colours, but my general advice would be to have each primary – red, blue and yellow – represented by two colours each. From these it is theoretically possible to mix almost all other colours you need. Nevertheless for convenience and occasional brilliance, colours such as burnt sienna, raw sienna, viridian, and light red can be added to a basic palette.

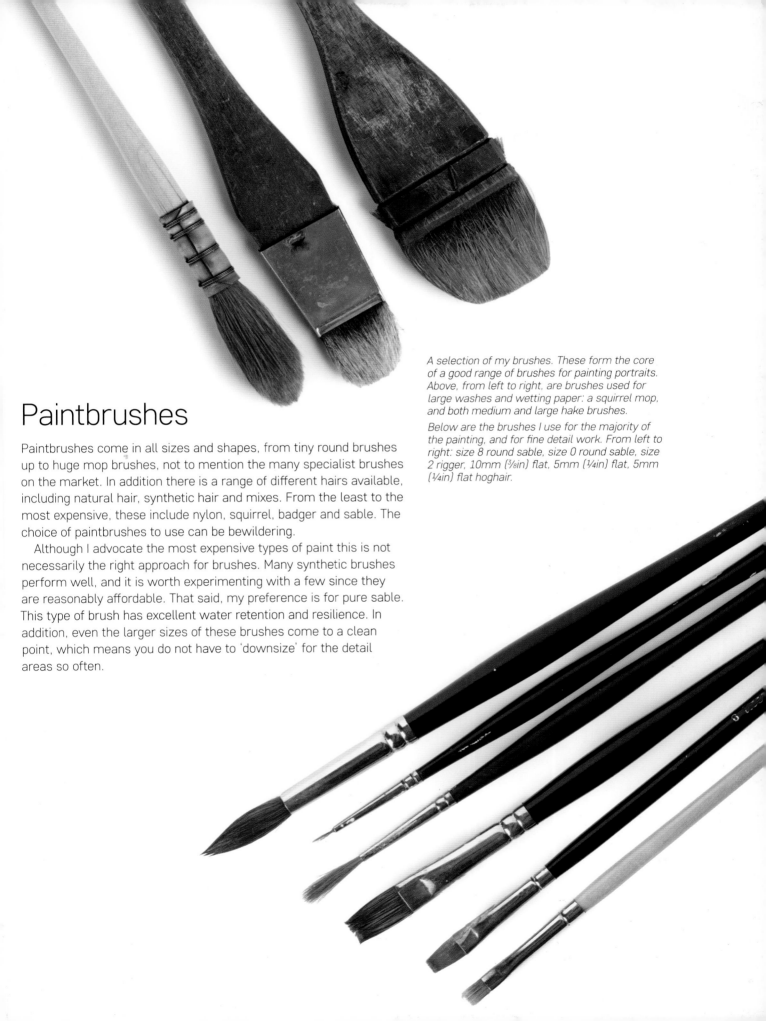

Paintbrushes

Paintbrushes come in all sizes and shapes, from tiny round brushes up to huge mop brushes, not to mention the many specialist brushes on the market. In addition there is a range of different hairs available, including natural hair, synthetic hair and mixes. From the least to the most expensive, these include nylon, squirrel, badger and sable. The choice of paintbrushes to use can be bewildering.

Although I advocate the most expensive types of paint this is not necessarily the right approach for brushes. Many synthetic brushes perform well, and it is worth experimenting with a few since they are reasonably affordable. That said, my preference is for pure sable. This type of brush has excellent water retention and resilience. In addition, even the larger sizes of these brushes come to a clean point, which means you do not have to 'downsize' for the detail areas so often.

A selection of my brushes. These form the core of a good range of brushes for painting portraits. Above, from left to right, are brushes used for large washes and wetting paper: a squirrel mop, and both medium and large hake brushes.

Below are the brushes I use for the majority of the painting, and for fine detail work. From left to right: size 8 round sable, size 0 round sable, size 2 rigger, 10mm (⅜in) flat, 5mm (¼in) flat, 5mm (¼in) flat hoghair.

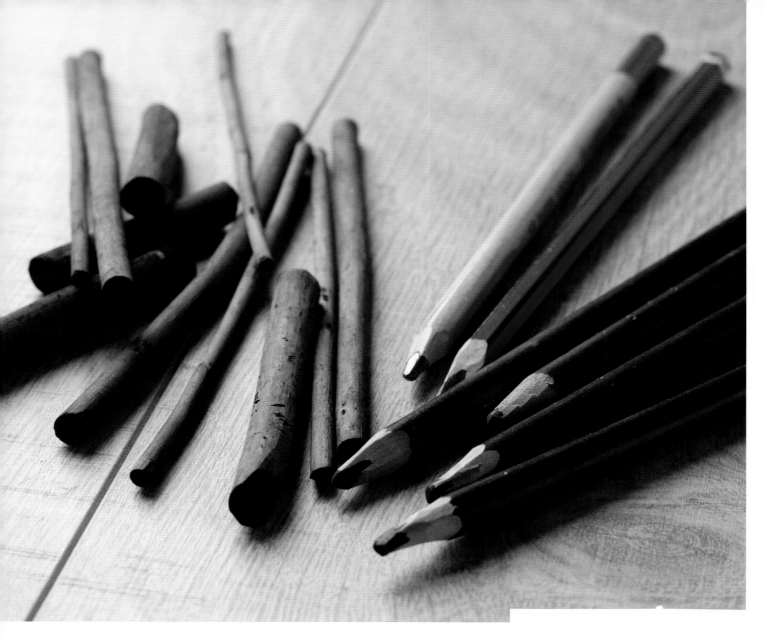

Pencils and charcoal

Graphite pencils

For sketching and the initial drawing for a painting I use a 6B graphite pencil. This produces quite strong darks when sketching, and the marks can be easily erased if necessary from a completed drawing or painting.

Charcoal

Charcoal can be bought in the form of pencils or as willow charcoal, a natural form which is usually obtained in a small box containing assorted sizes. Charcoal pencils are graded light, medium and dark, but I use only the dark. There is also, surprisingly, a charcoal white pencil. This will not produce a strong white, but is very useful for hair and similar fine pale lines.

Paper

Watercolour paper comes in various surfaces and weights.

Surfaces

The three surfaces available are hot-pressed or HP, which has a smooth surface; not pressed (commonly known as Not), which has a surface with some texture; and rough, which is relatively heavily-textured. Which you choose depends on personal preference, because although each surface is suited to particular techniques and therefore particular subjects, it is quite possible to paint any subject well on any paper.

I mostly use Not surface paper for portrait work as it usually requires subtle shading and close control. Hot pressed is fine for ink work — for instance pen and wash — but is not ideal for the application of several layers of colour. Rough is very attractive if you need broad effects — dragging a loaded brush swiftly across the paper can suggest many textures convincingly — but the surface is more suited to landscapes than faces.

Weights

Paper weights determine the thickness of a paper and are expressed in grams per square metre (gsm) or pounds per ream (lb). Some common weights include: 190gsm (90lb), 300gsm (140lb) and 638gsm (300lb). The heavier the weight, and therefore the thickness, the more resistant the paper will be to cockling when water is applied. Only the heaviest and most expensive will be immune to cockling, and therefore it is usually advisable to stretch the paper. This can be done using gummed tape and a strong ply board, or by a proprietary device such as a Ken Bromley paper stretcher, which is what I prefer to use.

For pencil portraits I generally use a medium or heavyweight cartridge paper. This will also work for charcoal, though I also like using the reverse side of hot pressed watercolour paper, which is less smooth, for some extra tooth.

Palette and easel

Traditional easels and palettes come in a great variety of designs, as an inspection of any online art suppliers' pages will reveal. The essential requirement for the easel is that it should be able to accept the weight of the board used to support the paper, and should be easily adjustable in angle. If there is also somewhere to place palette and brushes, so much the better, but these can also simply be set beside you on a table.

For many years I have been developing my own lightweight designs to combine these items. Although primarily intended for outdoor painters, its virtues of providing a seat, an easel, a shelf and storage, all in the one piece of equipment mean it works for studio painters too. No need to clear away a table for other purposes and no inertia to overcome when faced with setting up the next day. Many of the portraits in this book, and all the demonstrations, have been produced using it.

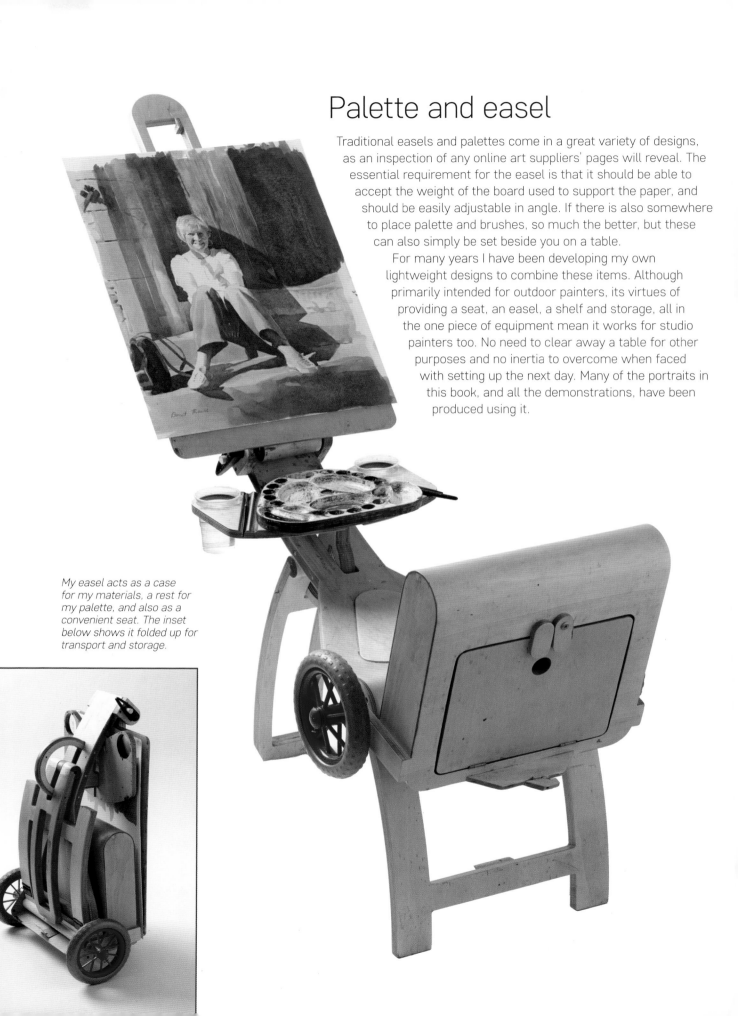

My easel acts as a case for my materials, a rest for my palette, and also as a convenient seat. The inset below shows it folded up for transport and storage.

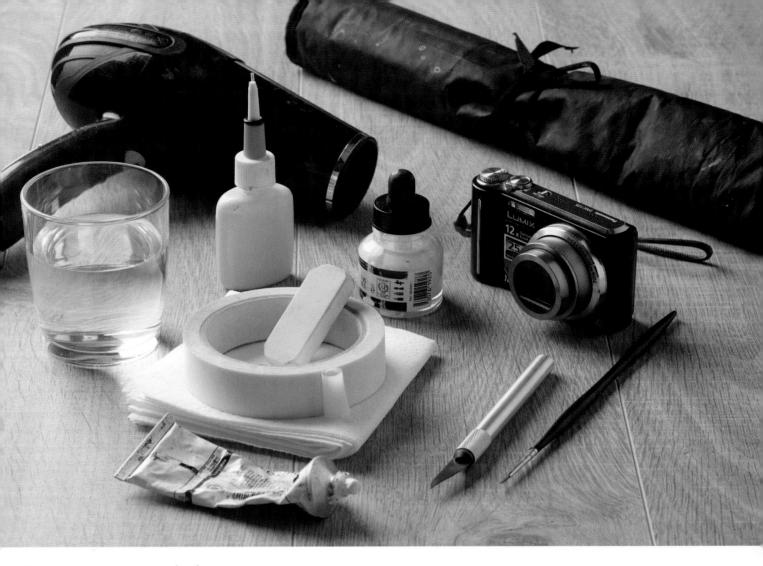

Other materials

Eraser Although in most portraits I will leave the initial pencil lines in place as they help to add character, they are best removed from delicately painted areas. A soft white plastic or putty eraser will do this without smudging.

Digital camera My camera is small and light enough to carry easily, and versatile enough to cope with any situation I might encounter. An optical zoom is another asset worth having. If the camera that has these features is also small and light, you have the ideal instrument.

Water pot Almost any container will do. I use plastic cups which drop into the holes designed for them on my folding easel. I also have the plastic concertina kind of water pot, which take up little room when collapsed.

Masking fluid and old brush This gum-based fluid is used to reserve clean white paper. It can clog brushes, so do not use your best ones to apply it.

Masking tape This is used to secure paper to the drawing board.

Craft knife This tool can be used to create thin white lines or small spots in a painting by cutting through the surface of the paper.

Kitchen paper Used mainly for cleaning the palette, it can also be used for lifting out and drying brushes. A natural or artificial sponge can be used for the same technique.

Opaque white White acrylic paint or white ink can be used to add white on top of watercolour.

Brush case There are many from which to choose. I suggest one generous in length, to allow room for storage of the bigger hake brushes.

Hair dryer Any kind will do. Generally it is preferable to let washes dry naturally, which encourages granulation, but a hair dryer allows you to dry a wash more quickly if necessary. Avoid the high setting, which risks moving the paint about.

Design

Design: *a conscious arrangement of ingredients to produce a desired end.*

We are used to seeing the term 'design' applied to everyday objects, large and small, across the whole gamut of fashion, architecture and product design. These are all three-dimensional creations, satisfying the practical needs of human beings.

As painters we are released from such considerations. Our concerns are visual, and the other senses – sound, touch, smell and taste – are not normally called upon. Freed from functional issues, we can concentrate on the form. Our brains react with pleasure to certain combinations of shape, colour and proportion. Manipulating these within the painting frame is what we are doing when we draw or paint.

As a branch of painting, portraiture does not encompass the variety of subject matter encountered by the landscape painter, nor have to tackle technical aspects such as aerial perspective. Our focus is on the human form, and the need to capture a likeness – a believable two-dimensional representation of the three-dimensional person. Successful portraits do more than make a recognisable image of the sitter. By choosing the pose, the lighting and the composition, the artist is designing the painting. These elements can suggest character and establish a mood. Bad design can spoil a technically excellent portrait, while good design will enhance it.

In this chapter, we explore the basic principles of composition and proportion, before looking in detail at the pose and lighting of the subject – all vital considerations in producing a successful portrait, whether drawn or painted.

Self-portrait
This was produced for a television programme on portrait painting. It is a controlled piece of painting enlivened a little by some loose brushwork.

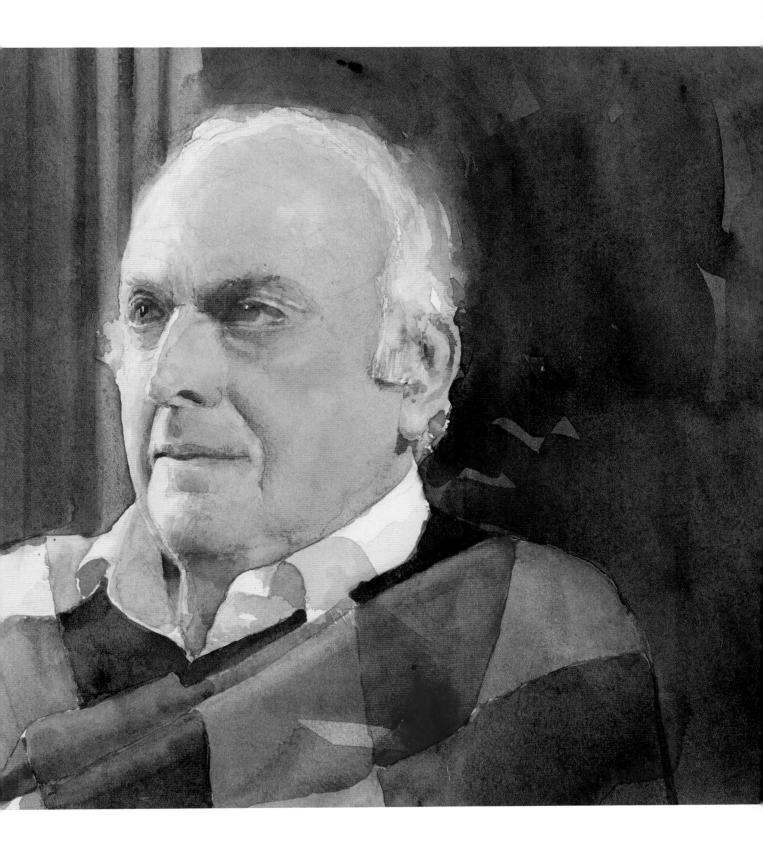

Composition

Composition could be defined as a pleasing arrangement of shape and tone. Colour does not have to be present – a well composed portrait will likely look just as good in a black and white version.

In portraiture compositions are often simple – typically the arrangement shows just the head, or the head and shoulders. Very often there is a plain background and achieving a successful composition becomes a matter of moving a temporary mount around it to find a final cropping arrangement.

Tip

Colour and tone are presented in more depth on pages 68–71.

Cropping

Two pieces of L-shaped card can be a means to find a final cropping solution. Simply lay the pieces of card over each other as shown here to experiment with different ways to frame the image.

 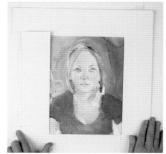

Placing the sitter in space

The two initial crops (below left) are unsatisfactory, being either too cramped or over-spacious. The final version, below right, has the head placed a little to the left, creating room into which the eyes of the subject can gaze.

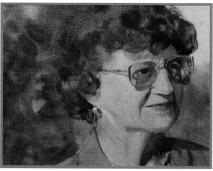

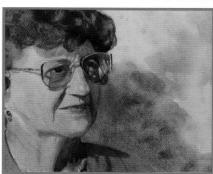

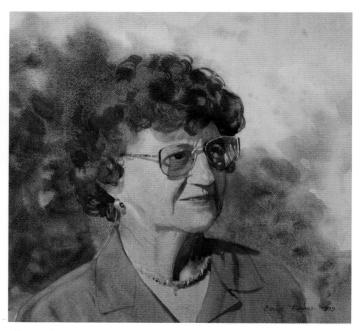

Eiluned

Putting your subject off-centre, as in this simple composition, is a good example of how you can balance the picture. Note that there is more space in the direction that the figure is looking. Compare this with the two alternative crops to the left, which feel cramped, over-spacious, or lead the eye out of the painting.

Creative composition

When three-quarter and full-length pose portraits are tackled, then there is more potential for an original composition with the placement of the figure. Originality should not come at the expense of common sense – so generally speaking you should avoid placing the figure so that it is cut off at the knees, or placing the head in the corner.

Look for a balanced design which observes the basic rules of composition illustrated below. These will be familiar to landscape artists, but equally applicable to the portrait artist when dealing with subjects more demanding than a head and shoulders arrangement.

Tip

There is an overview of common portrait poses on pages 24–29.

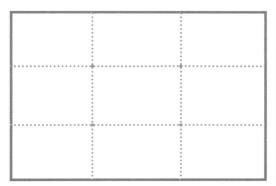

Landscape and portrait grids

The left-hand rectangle is a typical landscape format, while the right-hand rectangle shows a typical portrait format.

Focal points

The images to the left show rectangles split into nine equal rectangles by intersecting lines, each a third away from each edge.

The four large dots on each, where the lines intersect, mark natural places for the eye to rest – these are called 'focal points'. As a result, they make good places for the part of your portrait you want the viewer to look at, usually the face.

Using focal points

The portrait of this young woman could have been sketched in a conventional head and shoulders pose, as in *Eiluned* on the opposite page. This approach is shown in the left-hand image below. Note how the head sits in the central rectangle of the nine (see above), with plenty of space around it.

By moving the viewpoint further away, as in the example on the right-hand side below, the head can to be placed approximately on one of the focal points, making a more balanced and interesting composition.

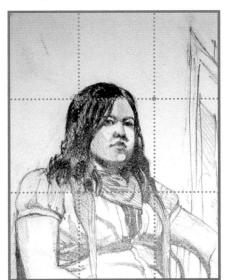
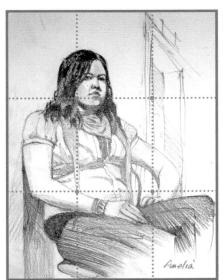

Compositional tools

Using a grid is a widely-used drawing aid, allowing images to be
reproduced accurately. You simply draw a grid of squares on the
reference image, then lightly reproduce an identical grid on your
painting surface using pencil. You can then use the grid to help guide
you when working out the relative size of shapes. If your photographic
reference is viewable on a computer, many editing programs will
allow you to impose a grid on it, saving time and allowing you to work
from your monitor.

The grid can be removed with an eraser once you have completed
your painting – as long as the pencil marks are faint enough, this can
be done without damaging the surface.

Although I prefer to draw freehand, I have used this method for
several portraits in this book, and it gives great confidence to know
you have an accurate foundation as you proceed to paint.

Tip

The grid can also be used to enlarge (or reduce)
an image, by making each rectangle of the grid
larger or smaller on your painting surface.

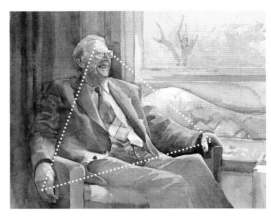

Ross

*Note the faint grid of pencil lines, left in place on this example to illustrate the
information above. The sitter is in a relaxed pose; here the head is a focal point
at the top of a triangle formed along with the hands, as shown in the inset. The
points of the triangle are the focal points, and they provide 'resting places' for the
eye so that it does not drift out of the picture as it wanders.*

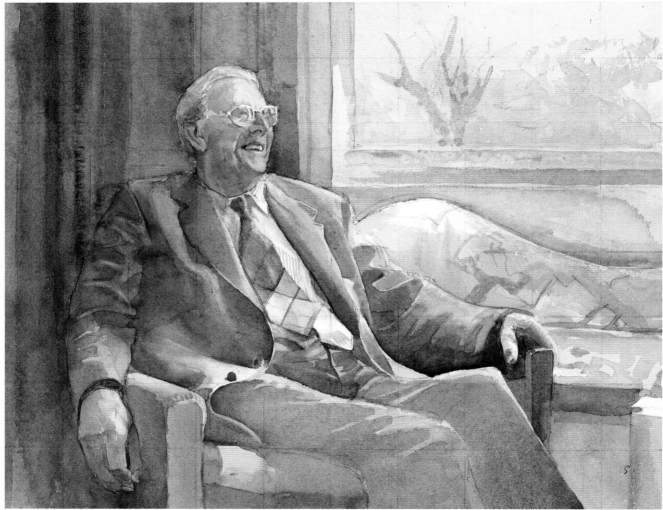

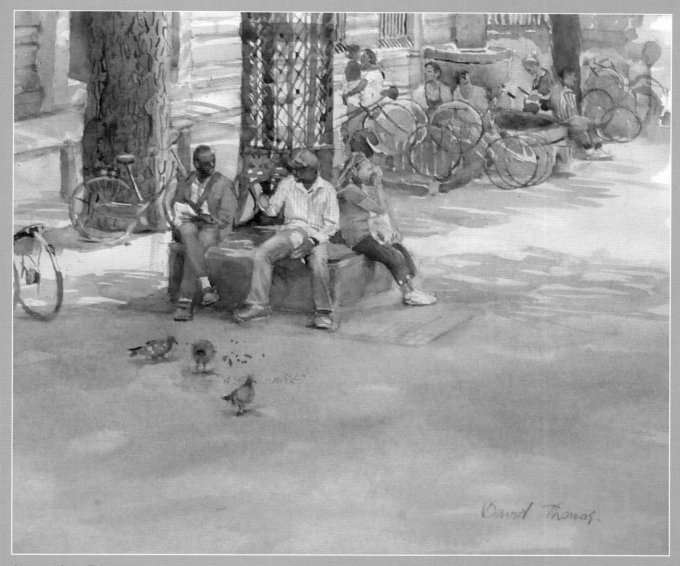

Amsterdam Trio

Lying somewhere between a portrait and a landscape, this is a subject where the context is as important as the people. Ethnic variety, bicycles and pigeons might have led the viewer to conclude this was Amsterdam, without knowing the painting's title.

As a composition, this bends the rules a little, since the group is neither centrally placed, nor quite occupies one of the focal points created by applying a grid (see page 17). If the group had been moved to the centre, or alternatively moved diagonally towards the top left corner so as to be one third from each edge, it would have been less successful I think. It is a reminder that there are no unbreakable rules.

Proportion

Proportion is the relation of the parts to the whole. In the human head the parts we need to relate to the whole are ears, eyes, nose and mouth. Our familiarity with these features has made us remarkably sensitive to small variations in their size and placement. This is the basis for our ability to recognise our friends and enemies. The adult head itself also has a constant ratio to the full height body, as illustrated on page 22.

The basic guidelines to proportion on the following pages will prevent major errors of drawing, but a portrait painter's work is in finding the subtle variations within these norms. .

Basic proportions of the human head

Human faces conform to consistent proportions, with only minor variations. Seen from the front, the skull's oval shape is contained in a rectangle which measures three squares high by two squares wide. The eyes lie on the centreline of the rectangle, which also marks where the top of the ear joins the head. The next line down defines both the point where the lobe of the ear the ear joins, and the bottom of the nose. These basic proportions can be seen in the photograph on the top right of this page.

The side view, or profile, shows the head measures approximately three squares high by three squares wide.

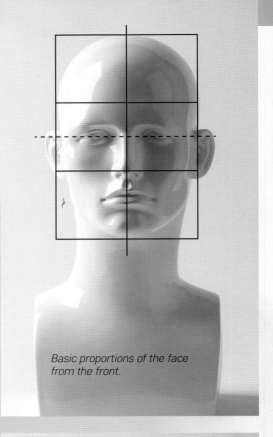

Basic proportions of the face from the front.

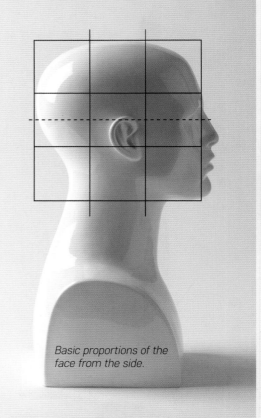

Basic proportions of the face from the side.

Viewing height and face angle

Changing the viewer's eyeline affects the character of the portrait, and can be used to accentuate or subdue particular features. In particular, note how the position of the ears moves noticeably as the eyeline alters.

Full face view

Full face means a square-on view. Because the features are contained within the oval of the face, particular demands are made on the artist's abilities. The nose and chin, for example, must be described by tonal variations, since they are not seen in outline, as in a three-quarter or profile view.

 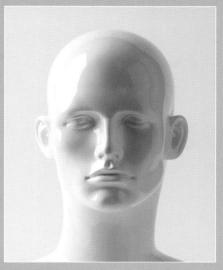 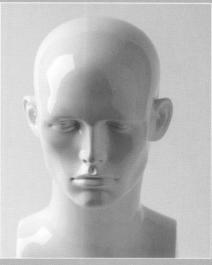

The head from a low viewpoint. This accentuates the chin, and can lend nobility to the countenance. This effect is more striking in the three-quarter view (see below).

The head from a level viewpoint. This objective view is neutral, emphasising no particular feature. As a result, arguably it provides the least information despite being the required pose for passports!

The head from a high viewpoint. This will naturally accentuate the forehead and might be a good viewpoint to choose if the subject has a striking head of hair.

Three-quarter face view

The three-quarter face pose means the head is turned to be halfway between full face and profile. It best captures the form of the skull as well as providing information about the shape of the ears, nose, eyes and mouth. As a result, it is a good starting position for many portraits.

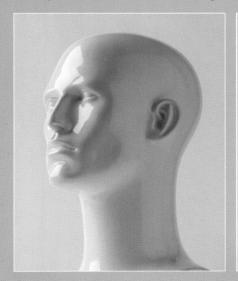 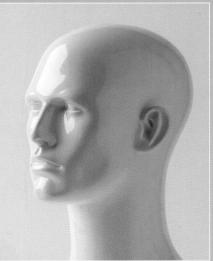 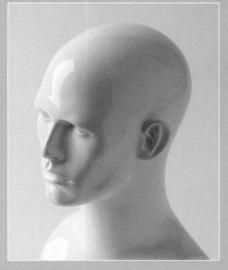

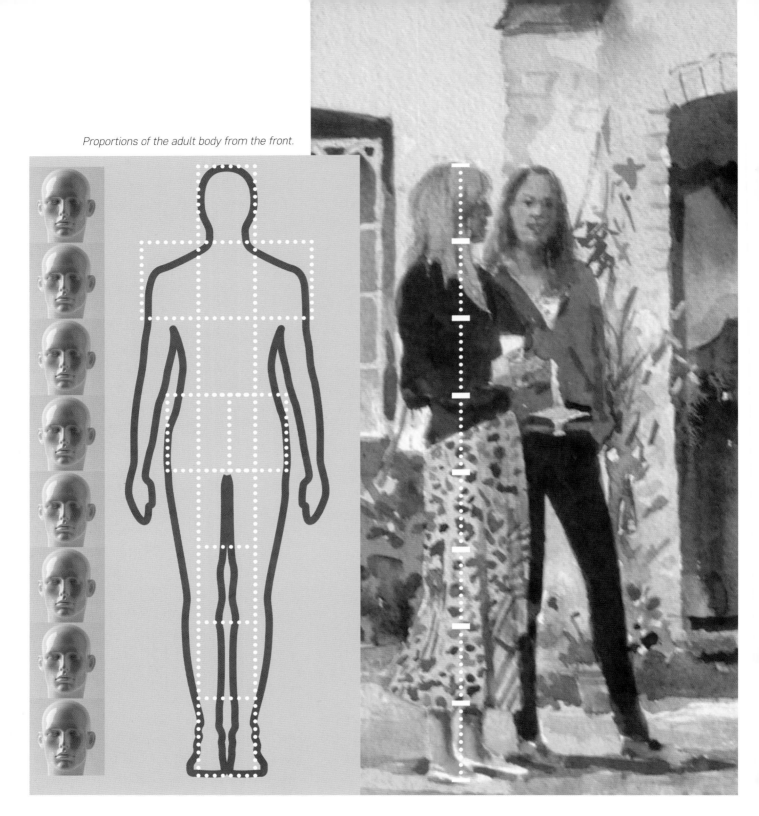

Proportions of the adult body from the front.

Basic proportions of the body

For full-length portraits, a basic understanding of the proportions of the body is important. A good way of working out some rough guidelines is to use the height of the head as a measure. As shown to the left, the standing figure is approximately eight heads high; and the width of shoulders and hips can be approximated by using the rectangle enclosing the head – the shoulders being equal in width to three heads, and the hips equal to two heads.

Mother and Daughter

This full-length double portrait effectively demonstrates the general rule that the head is approximately equal to one-eighth of the overall body height. The overlaid marks show the height of the body compared with the head.

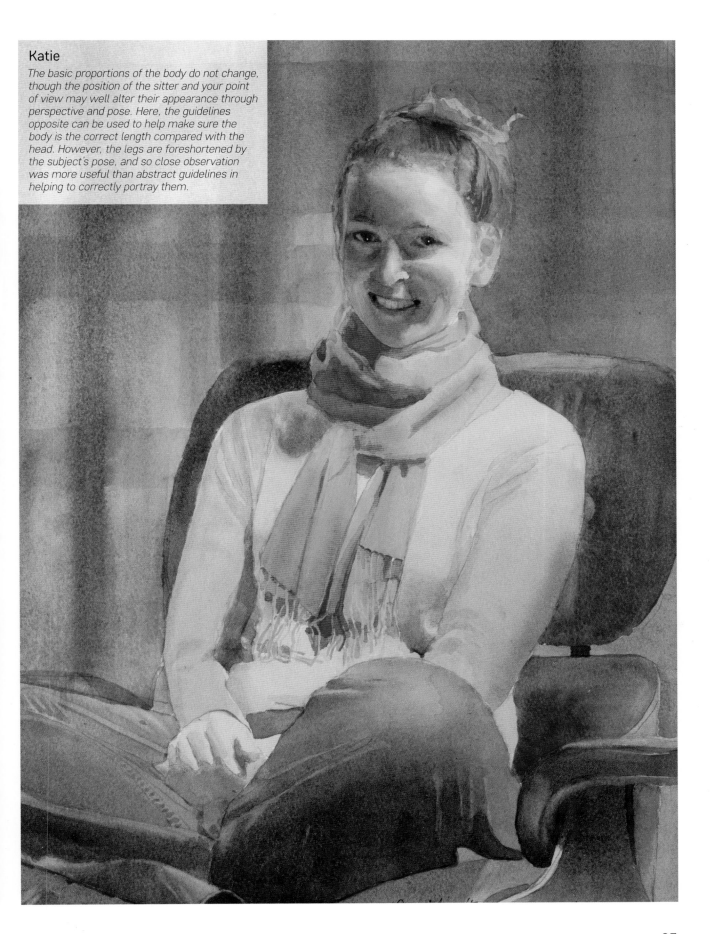

Katie

The basic proportions of the body do not change, though the position of the sitter and your point of view may well alter their appearance through perspective and pose. Here, the guidelines opposite can be used to help make sure the body is the correct length compared with the head. However, the legs are foreshortened by the subject's pose, and so close observation was more useful than abstract guidelines in helping to correctly portray them.

Pose

Portraits can be divided into several types or formats: head; head and shoulders; three-quarter length; full length and groups. The decision of which pose to use might be suggested by the sitter (see the *Portrait by commission* box, right), but if the final choice of pose is up to you, it can be difficult to know how to make such a fundamental decision. Once you have made the decision you are left with the two remaining variables of lighting and background, which are covered on pages 30–33 and 34–37 respectively.

Each type of pose offers its own advantages and challenges. In order to help you choose a suitable format, the following pages explore some examples of each, along with notes on when you might choose to use a particular one.

Portrait by commission

It is often the case in portrait work that your subject is also your client, and has an opinion about the pose. Perhaps they are adamant that what they require is a head and shoulders depiction of themselves.

Now at least you only have to worry about whether you should view the sitter in profile, full face or three-quarter, and at a high or a low level. When the artist is asked for – or suggests – more than head and shoulders, greater opportunities for creative compositions arise. I often think of John Singer Sargent in this respect, whose compositions involving groups were inventive and brilliantly executed.

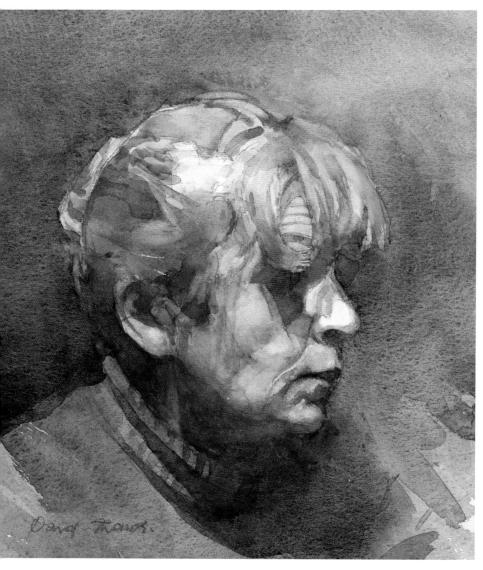

Head

As you might expect, this portrait type is focused on the head alone, to the exclusion of the rest of the body. It can be a profile view (as shown to the left), three-quarter (see *Eiluned* on page 16) or full face (see *Trefor* on page 39). Such close-up studies can sometimes seem forensic in their detailed examination of the features. Self-portraits from life tend to be full face as the artists uses a mirror for reference.

Many artists have painted themselves regularly and left a unique record of their progress through life to posterity. The artist Rembrandt van Rijn's famous series of self-portraits are outstanding examples of honesty in painting, tracing his passage through life from youth to old age with unflinching accuracy. Perhaps because many self-portraits are inevitably full face, looking directly at the viewer, it is this view that can best lay claim to provide psychological insight, though I am dubious, and make no such assertion for my own work.

Erica

This head portrait shows a profile (side) view. There was very little light available for this informal, indoor shot, and what there is comes from overhead, casting the eyes into shadow. It makes for a dramatic painting, though a less directional light would have been more flattering for the subject.

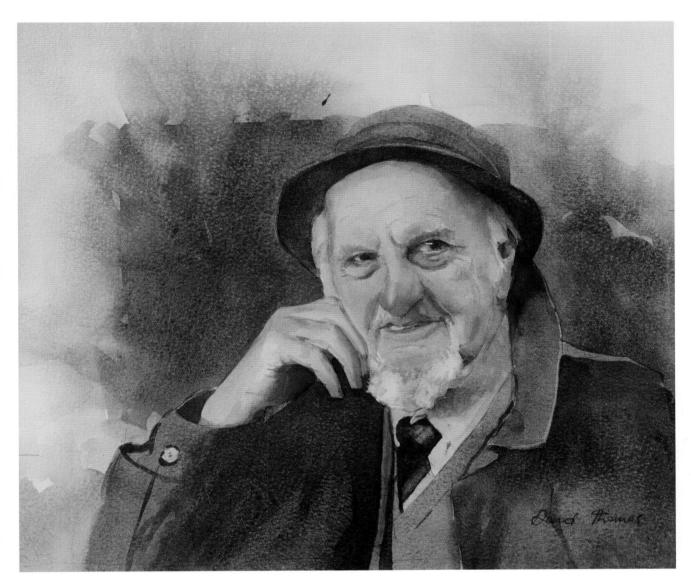

Head and shoulders

This is perhaps the most widely adopted form of portraiture because isolating the head can produce an unnatural look. Including the shoulders and one or both hands, tells something more about the subject. It introduces 'body language', which is sometimes as informative as the face.

Hands can play a significant part in the composition – as in the example above – in adding or emphasising character. They are a challenge to paint well, and judgement is needed not to let them compete for attention with the face, but rather to complement it.

Elderly gentleman

This was painted from a photograph of a man arriving to pick up his wife from a portrait class both she and I had been attending. He was a striking figure whom I asked to pose briefly, and his hat, coat, hands and weatherbeaten face all add up to a good composition. If you compare the background with that of Morydd on page 1, you may notice a similarity.

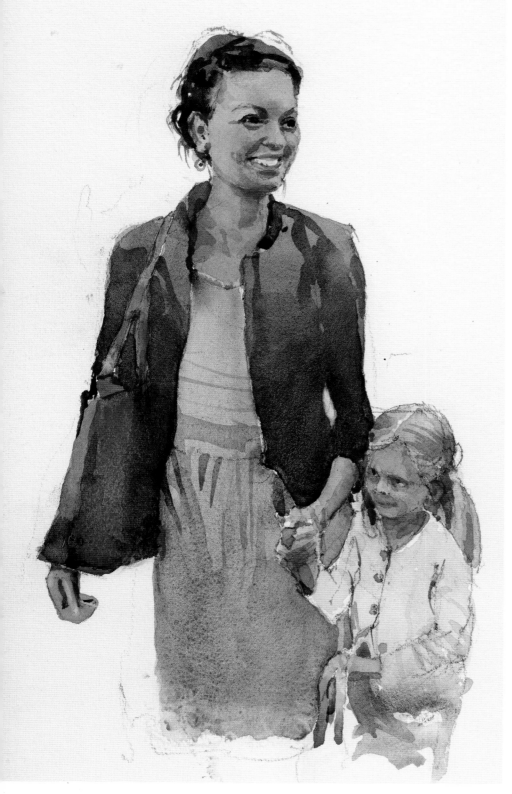

Three-quarter length

This format, which omits only the lower legs and feet, offers many compositional opportunities – *Ross* (see page 18), *The Casson Sisters* (see page 30) and *Pair at Patchings*, to the left, show just three examples. Subjects who are sitting usually fall into this category, but the pose often works well for standing figures, too.

The three-quarter-length pose also brings the hands into play. The head becomes less important, but it is still usually the focal point, and care must be taken to see that the hands do not compete with it. In the case of *Ross*, they form a pleasing triangle with the head. In *The Casson Sisters* only one hand appears, which is greatly simplified. In *Pair at Patchings* all four hands are visible but they are not a distraction.

Pair at Patchings

This painting was made from a photograph taken when these two visited my stand at an art festival I attended. The light was bright but diffused through the marquee roof, giving a lovely glow to the portrait. The differing height of the mother and child meant a three-quarter-length pose was well-suited, giving each figure equal importance to the overall composition.

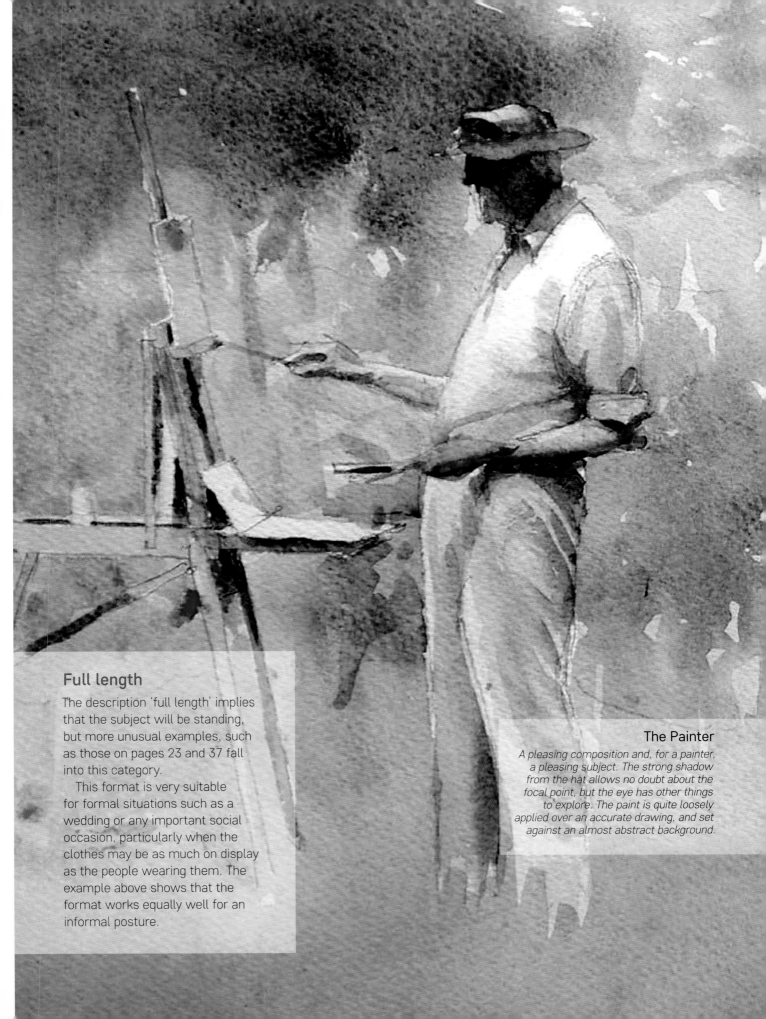

Full length

The description 'full length' implies that the subject will be standing, but more unusual examples, such as those on pages 23 and 37 fall into this category.

This format is very suitable for formal situations such as a wedding or any important social occasion, particularly when the clothes may be as much on display as the people wearing them. The example above shows that the format works equally well for an informal posture.

The Painter

A pleasing composition and, for a painter, a pleasing subject. The strong shadow from the hat allows no doubt about the focal point, but the eye has other things to explore. The paint is quite loosely applied over an accurate drawing, and set against an almost abstract background.

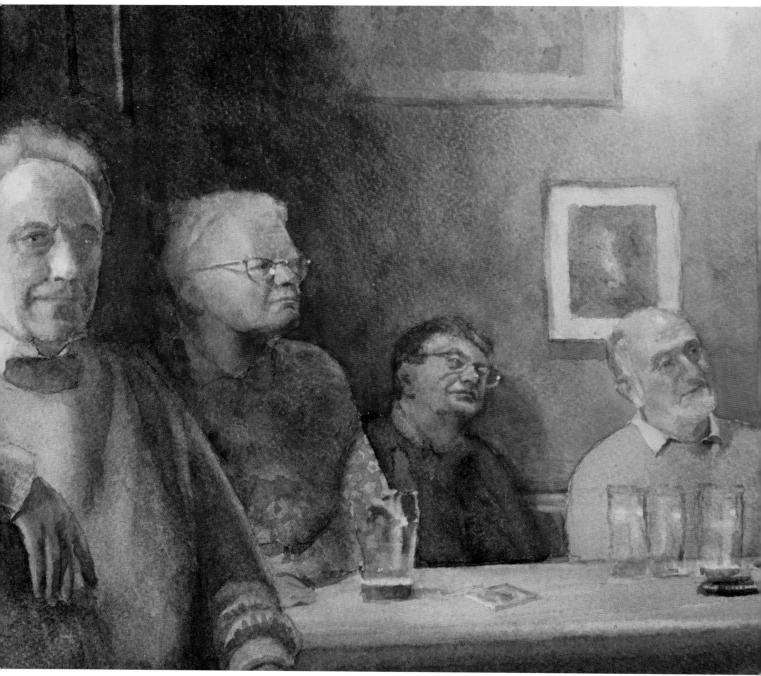

Group poses

Group poses can be technically and logistically challenging. The technical challenge revolves around creating a focal point. In the *Group Reunion* painting on pages 2–3, one of the figures is isolated, which causes him to become the focal point. In the painting above, the focal point is Lionel, the figure second from the right. It is created through a combination of placement, contrast, of the face against the background and the group's attention on him.

The logistical challenge arises because controlling so many people is difficult. In the examples in this book, no formal arrangement was attempted. This ensured an informal portrait, with the subjects (myself excepted) unaware of the camera. My control was limited to what I did in editing reference photographs later.

A digital camera is a near-essential tool for group portraits, as painting from life will almost always be completely impractical. More information on painting from photographs can be found on pages 74–81.

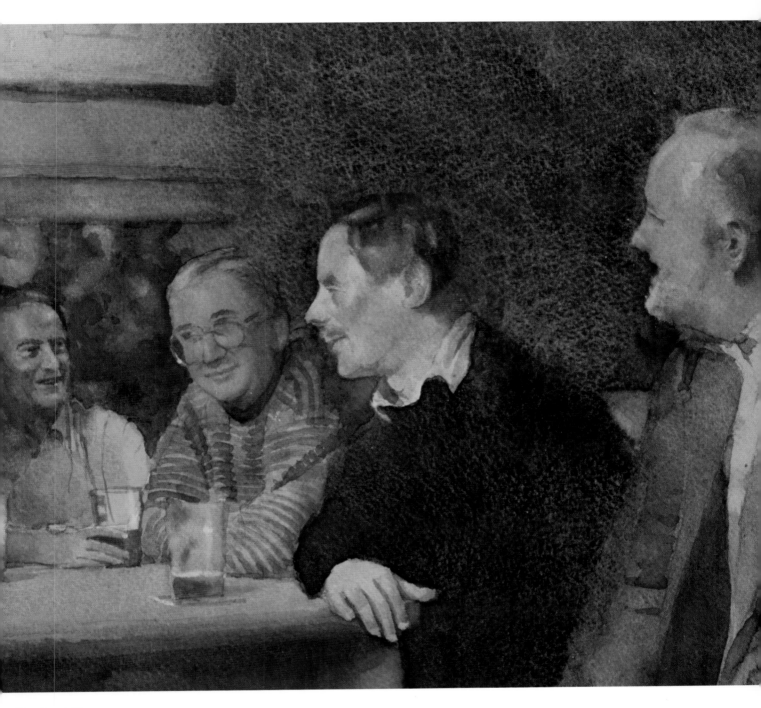

The Last Suppers

This record of a meeting between ex-employees in a famous local pub, was painted from a composite photograph. My first session using a tripod mounted camera, required a timer so I could be part of the group (on the left) and had everyone facing forward. Of those exposures, only my own image was retained. I realised that it would make a better composition if most were seen in conversation, so I went back to the camera for another round of photographs. A latecomer then arrived and I recorded his presence.

At home I manipulated the images to produce a final version, which was the basis for the painting here, produced over the course of three days. The painting is large – over 1.5m (1½yd) across – which can be attributed at least in part to the necessity to have a large area to fit so many people in. A framed print hangs in the pub, in the room portrayed.

A focal point is not easy to arrange in a large group painting, and here it falls on Lionel, in the dark jumper. His position, the lighting and how most of the group are looking at him, all contribute.

Lighting

The objective of the portrait artist is to find a design which captures the essence of the sitter, and lighting plays the crucial role. In fact, without light there can be no painting – no composition, no colour.

It can be single or multi-sourced, natural or artificial, dramatic or subdued. Complete control of all these aspects will not be possible, unless you have the facilities of a photographer's studio and a sitter willing to come to it. However, even if both the time and opportunity to alter the lighting are limited, a mind alert to the possibilities of the particular situation is what will bring results.

Natural lighting: outdoors

Outside light can vary from soft and diffused, as in an overcast sky or a misty morning, to the harsh glare of nature's giant spotlight at midday. If it is possible to choose both time of day and the weather then you can pick the perfect conditions for good work. In practice you will not be so much in control, and will have to adapt to the situation.

Being outside can often mean freedom of movement and therefore the potential to explore different settings. The light direction may be fixed, but the model is less confined than in a house or studio, and can be moved and rotated to find the best combination of background and lighting.

A minimum requirement for outside photography is no rain and reasonable temperatures. An overcast sky will not produce the strong modelling (a term that describes the ability of light to suggest form) which direct sunlight or stage lighting will create. For some faces, particularly the elderly, this may be kinder.

Soft lighting can work for children too, as in the example on page 84, where the unblemished skin and subtle colouring need no dramatic emphasis. In *The Casson Sisters* (see right) however, strong direct sunlight brought out their features well.

The Casson Sisters

This portrait began indoors, with the children playing with their toys in the lounge, but no strong arrangement came from these initial images. Moving outside into the sunlight proved to be the answer, where the mutual affection of the sisters could become apparent, and the natural lighting added to the informality of the situation.

Natural lighting: indoors

A traditional artist's studio would receive a large amount of northern light, which gives an even and diffuse illumination during long periods of the day. Such artists would probably be landscape rather than portrait painters, who will want, at least occasionally, a more direct light falling on their more intimate human landscapes.

As a portraitist, you will often visit your subject in their own home, where you will have to respond to the conditions and opportunities you find. The light from a window, striking the face from one side, can produce beautiful modelling of the features, for example.

The furniture and décor of an indoors environment may suggest a background, which may, in turn, prompt ideas for a pose. This background can identify the house for future generations, and should be given due attention. Try to ensure that the lighting produces the right balance between figures and background.

The Douglass Brothers
Two brothers posing in their home. The gentle light on the curtain behind them was all that was required in this diagonal composition.

Artificial lighting: ambient lighting

Ambient lighting is simply the light available in an indoors environment. Without directed light, indoors lighting tends to be a little dimmer than outdoors lighting, and more directional. The lighting is rarely ideal, but sometimes an unplanned opportunity arises to take a photograph which will be used for a painting. This is often at social occasions, where there is artificial light. There is usually no opportunity to pose the subject, but with digital photography and a quick eye, many striking compositions can be found.

This is where the digital camera comes into its own. Set to high sensitivity, and running off many rapid shots, I have always been surprised when reviewing them at home later. The most successful when being assessed for a potential painting are not the ones I made a mental note of at the time, but some other shot which caught a fleeting expression or an informal moment.

Beryl

This painting of my wife was painted from a photograph taken while she was in conversation with her brother in a pub. The light was poor, but the camera, on a high sensitivity setting, has captured an expression which is true to life.

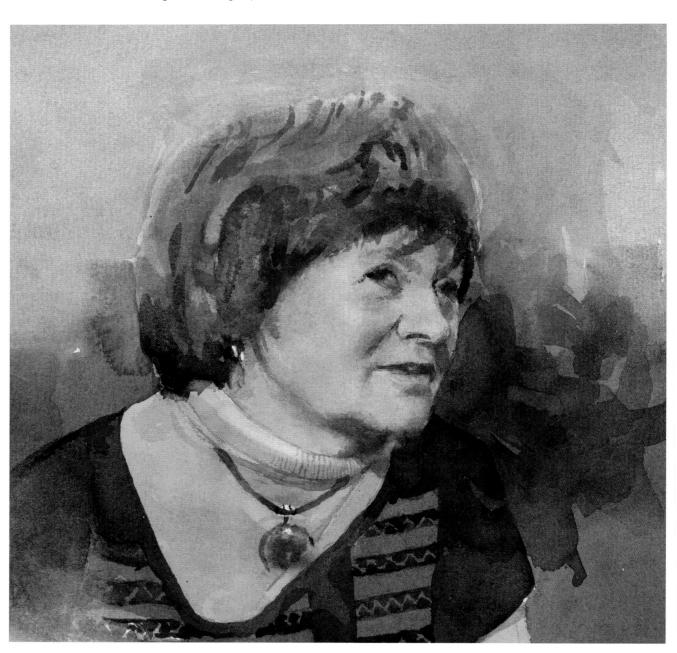

Artificial lighting: studio lighting

In contrast to using the ambient lighting of an indoors environment, you can set up artificial lighting with a view to creating specific effects. Having control over the angle and intensity of light can give you complete control over the mood and atmosphere of the portrait you are painting.

On many occasions I have painted in portrait classes where a studio light has been used. One advantage of controlled lighting is that it, along with the model's pose, can be re-created should your portrait run over more than one session.

Studio lighting might seem like the domain of the professional photographer, but some basic lighting equipment, such as a directional lamp and a diffuser to soften the shadow on the side of the face, can give good results with only a little practice.

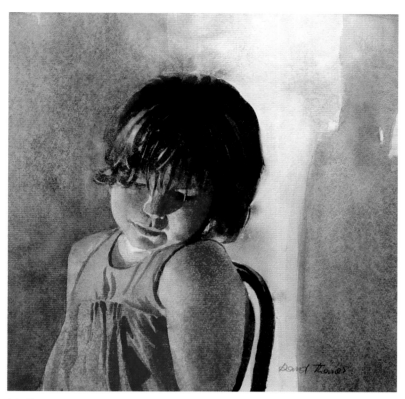

Molly
Lit by a single photographic floodlight, a strong contrast occurs between the young girl's hair and the brightly lit wall, which is interrupted by the cast shadow.

Dramatic or unusual lighting

Dramatic lighting is naturally associated with stage and screen, and is therefore also the province of the professional and cinematic photographer. Such lighting can be subtle, but often simplifies shapes to deliberately emphasise the features of a strong face or perhaps an old one. As a result, such dramatic light is generally more appropriate for male than female subjects. In any case, a strong single light source will produce strong contrast, and by extension, striking results.

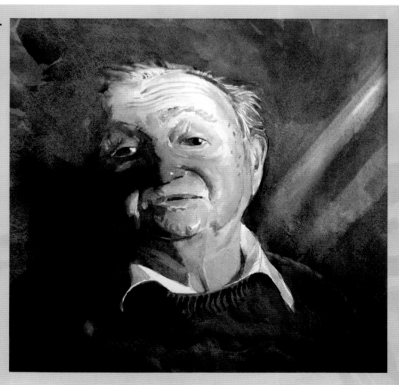

A Holocaust Survivor
This was painted from a paused television film. The left side of the face has areas which are very dark and therefore without detail. The effect is appropriately dramatic.

Backgrounds

Backgrounds can play an incidental or a crucial role in portraiture. They can supply context, locating the sitter in a particular place or building. They can be necessary to complete the composition, providing balance so the portrait can be effective as a painting, lifting it above merely a record of an individual.

In general terms, backgrounds grow in significance as the composition moves from head to full figure and groups. It is also generally better to have planned the background before beginning your painting, and to work on it alongside developing the main subject.

In watercolour, contrary to a common assumption, many adjustments are possible by lifting out with a brush or, more drastically, with a sponge. These techniques are described later in the book. Plenty of painting backgrounds, and sometimes chunks of the main subject, have survived such methods. Indeed, many have been improved by them, and nobody has been the wiser. Good paper and an acceptance that the virgin white will never be retrieved are the only stipulations. Happy accidents are to be preserved, unhappy ones remedied!

David Taylor

An exterior setting for an informal portrait, this painting portrays the fine watercolour painter David Taylor during a painting holiday in Italy. David is shown here with one of the ancient buildings of Spoleto in the background.

Sometimes the background serves more than one purpose. Here, apart from playing an almost photographic trick by producing a contrast between the sharp focus of the face against architecture in soft focus, it sets the portrait in a place and a time.

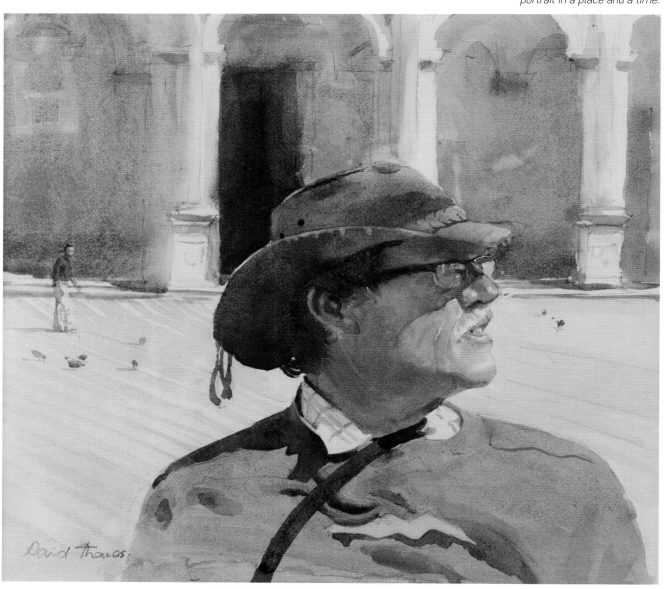

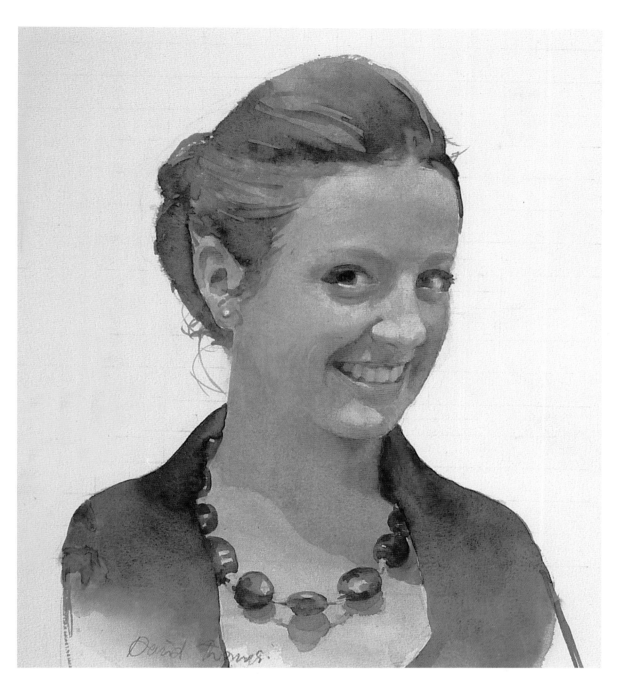

No background

A strong subject can tolerate a lively treatment behind it. A sensitive face cannot; and a head or a head and shoulders portrait which mostly fills the frame often does not need a background. The portrait of Lauren on this page is an example.

In a tonal work, a background can easily begin to compete for attention. For this reason, backgrounds do not have such an important role in drawings as paintings. A shadow thrown against a wall or backdrop can be effective. A pale face can sometimes be set against a darker background. But generally, less is more.

Lauren

A commission. A meeting was arranged with this young lady, the daughter of a friend of my wife, at a wedding reception. I took her away from the throng to a corridor, which had harsh unfriendly lighting. To overcomes this, I placed her so she was illuminated mainly from a single light source, which emphasised her attractive features. Some adjusting of the skin tones was required in the painting process to get rid of the colour cast.

In electing to paint her with no background, the hard lighting can be interpreted as strong outdoor sunlight rather than the artificial lamps of the corridor – for a more pleasant finished portrait.

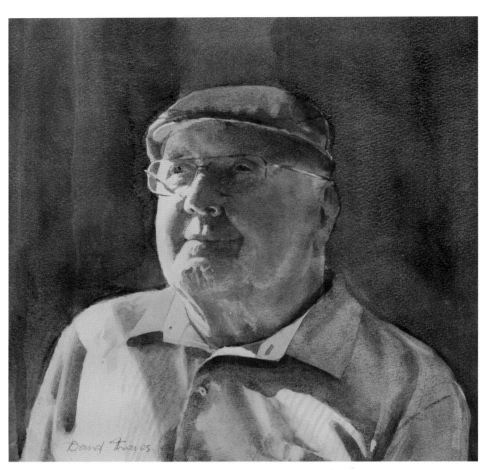

Strong or abstract backgrounds

As mentioned on the previous page, a subject with strong features can command a central role even against a very strong background.

This strength can be created through use of strong tones, striking colours, or an abstract approach, as in *Rowley*, below. If you choose to pursue this avenue, a big brush and complete commitment are the weapons needed for success.

Elderly Gentleman

Strong features can stand a strong treatment. Tonal counterchange between the dark background and lighter figure helps create impact.

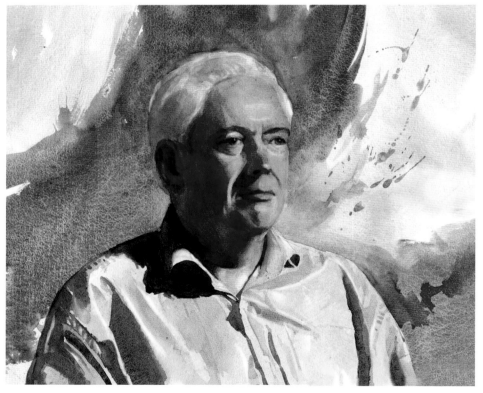

Rowley

The strong features and high contrast of this sitter merited an animated background.

Realistic background

Many family portraits are as much about the place as the person, and a realistic background serves to identify the location.

 In the example of *Jo* (see right), it is essential to the story the picture is telling. In the case of *Beryl* (see below) it serves a triple role. Each case should be considered on its merits, and if you are painting for a client, their wishes regarding it should be a priority.

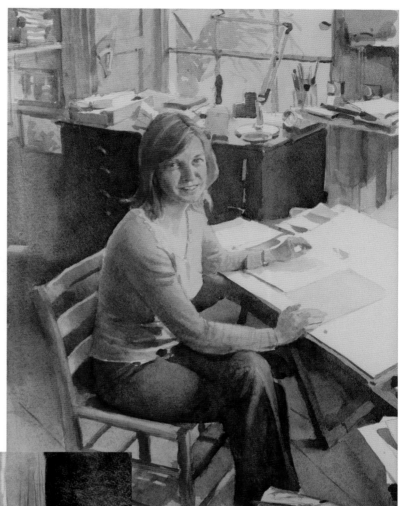

Jo

This shows the studio of the artist James Fletcher-Watson, in his Cotswold home Windrush. It has been left unaltered since his death. The background here is an essential part of the painting, as important to the success of the finished portrait as the presence of his daughter, sitting at her father's drawing board.

Beryl

This shows my wife outside Holy Trinity church in Langdale in the Lake District, UK. The background plays three important roles. It identifies the location, it throws out Beryl's white shirt and not least it makes it a painting as much as a portrait.

Using line

Lines do not exist in nature, and in drawing we accept the convention that uses a line to mark the boundaries between tones and colours. In the simplest drawings, as in a child's attempt to represent a face or figure, or even an artist's rough sketch, no attempt is made to introduce tone. In more deliberate and ambitious works, the lines merge and disappear as the form is subtly described by light and shade.

Sketching and drawing as we understand them did not become common until around the sixteenth century, when drawing paper began to be mass-produced, and artists such as Leonardo da Vinci and Albrecht Dürer could produce works that reached the summit of artistic expression.

Black and white portraits, drawn with pencil or charcoal, have a quality and appeal that make them very distinct from full colour watercolour portraits. In this chapter, we bring together the lessons on design, proportion and pose from earlier in the book and begin to apply them to our first drawn portraits.

Opposite:
Trefor
This drawing uses the full tonal range of charcoal. This is evident in the deep black on the hair and shoulders, but also in the eyes, where a reserved white highlight is set against a dark pupil.

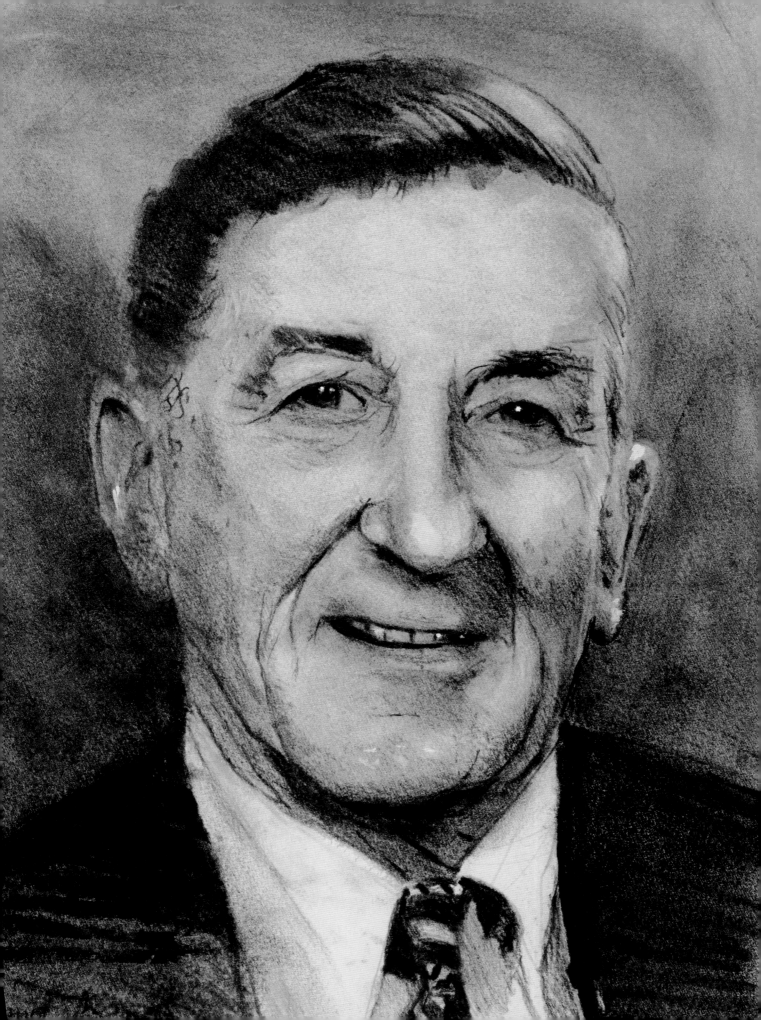

Sketching

If you have already a facility for drawing, sketching is a pleasurable activity which you may well already enjoy. It does not carry the responsibility of a finished work and is a means of self-expression without strain. Sketching from photographs has advantages of its own, which are explained later in this section of the book, and it will also prepare you for the more challenging – and more rewarding – task of drawing from life.

If you are not naturally gifted at sketching, do not despair! Practice is the key. Carry a small sketchbook, a soft pencil and a pencil sharpener around with you and draw whenever you have a spare moment. If you are able to adopt the habit of sketching, you will gradually discover it becomes easier and more pleasurable.

All sketching is beneficial. Any subject that appeals to you will eventually feed into your drawing and painting habits, but sketching faces and figures will clearly be of more direct benefit to your portrait drawing.

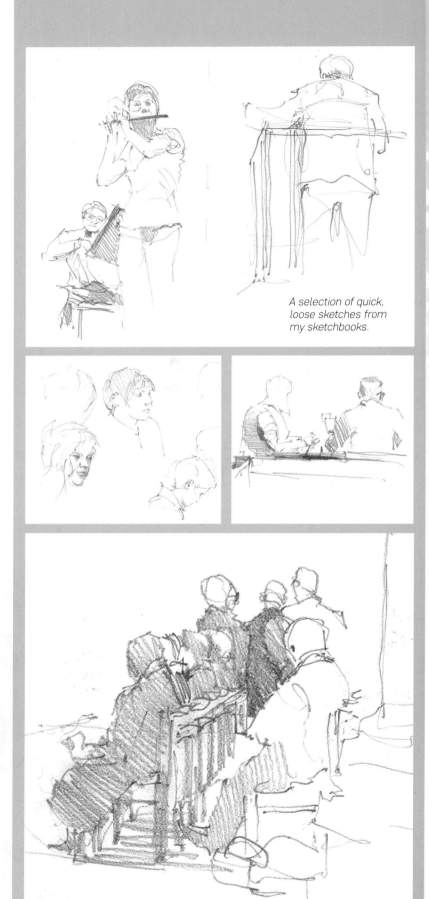

A selection of quick, loose sketches from my sketchbooks.

Group in Beverley Minster

This sketch shows a section of a congregation in the Minster, where the natural light is low level and diffuse. It had the potential, if a hint of the architecture had been incorporated, to make an interesting painting.

40

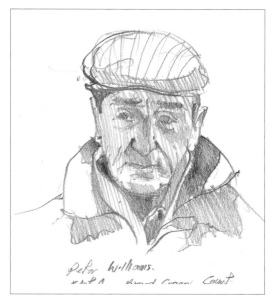

Peter

I was in a Dublin pub, and saw this lived-in face, the expensive looking clothes contrasting with the bleary eyes. Striking up a conversation led to him posing for a drawing. The later watercolour portrait, which can be seen to the right, used both the original photograph and this quick sketch from life as references.

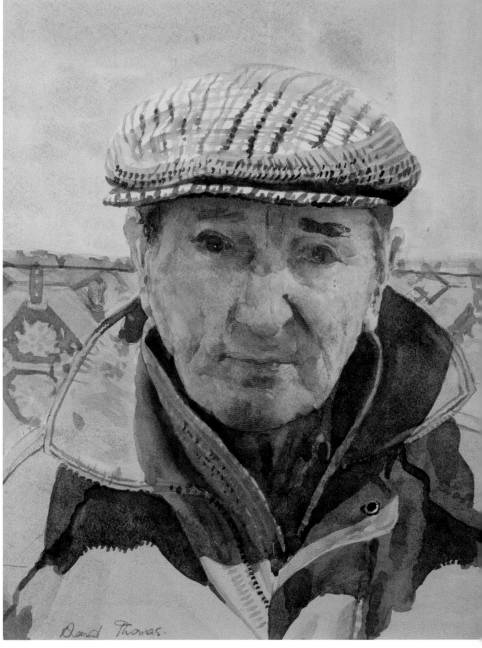

Sketching strangers

I have often sketched people without their knowledge when in a public situation, either in a pub or restaurant, or outside in a railway station or park. Usually the situation is such that it does not seem intrusive. Of course, you can always approach the person to see whether they mind, but in general, sketching people when they are unaware makes for more natural and unposed results.

Sketching the people around you can be an enjoyable and valuable way to practise your portraiture. The skills to work upon are speed and accuracy. When portraying the full or seated figure, body language becomes more important than facial features, and a few accurate yet expressive lines can convey this. Achieving speed whilst retaining accuracy has a double advantage – the line is likely to be more expressive, and the subject is less likely to leave before you have finished.

Drawing from life

If we think of sketching as an unconstrained activity, which tries to record a scene with brevity and spontaneity, then drawing is a more considered process. Sketches belong, naturally in a sketchbook. Drawings can sometimes be found there too (there is no firm division between the two), but mostly they deserve a separate piece of paper and a little more time.

Drawing from life does not need to be organised or pre-planned. I have made many drawings of friends and acquaintances in informal settings, and have drawn musicians – which, with their instruments, I find make particularly attractive subjects – from my seat during orchestral concerts and at rehearsals. For such studies, ten to twenty minutes may suffice.

Portrait and life drawing classes, which I have attended regularly for many years, offer an opportunity to draw from the model, devoting perhaps the whole session to a single drawing. Many factors conspire to make this the most demanding environment in which to work. A crowded class can mean you may not be as close to the model as is ideal. Background noise and chatter can be distracting. The model may not hold the pose, or may not resume quite the same position after a break. Even if these factors are not present, accurately transferring a face seen in three dimensions onto paper in two dimensions is surprisingly difficult. Nevertheless, tolerating and endeavouring to rise above these obstacles is worth the effort, and is rewarded in your greater confidence in drawing. Drawing freehand from a photograph, by comparison, is a doddle.

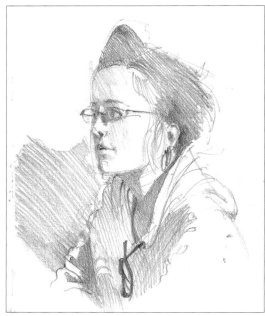

Molly
Drawn during a portrait class, this took around forty minutes.

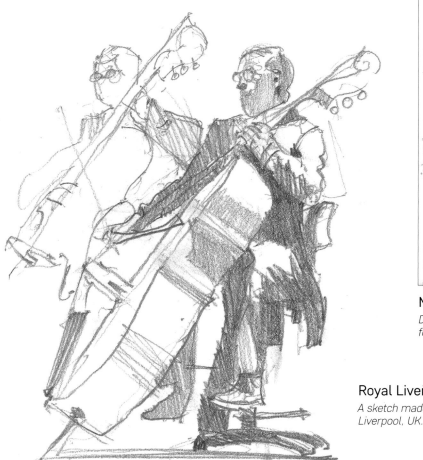

Royal Liverpool Philharmonic Orchestra
A sketch made from my seat during a concert in Liverpool, UK.

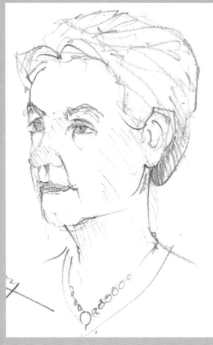

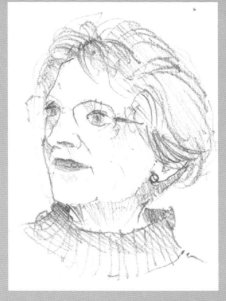

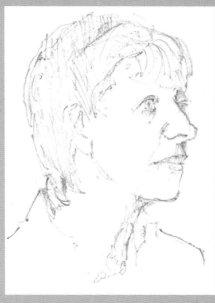

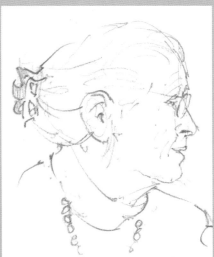

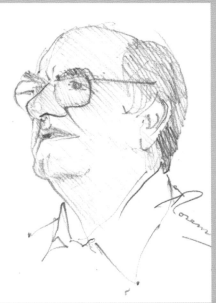

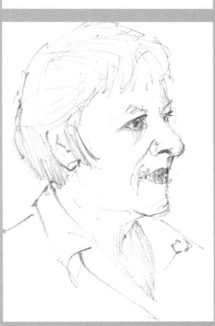

Quick drawings from life

These eight people were all fellow members of a painting course I attended in a Cotswold village. At the course's conclusion, I sketched all of the attendees.

In contrast with the unposed images shown on the facing page, each sitter posed for ten minutes. Posed drawings offer different advantages and pressures compared with unposed sketching; including a self-imposed time limit, and the sitter's awareness that you are drawing them – which can make some people tense and forced-looking. The artist's skill at putting the sitter at ease is thus of importance for such an approach.

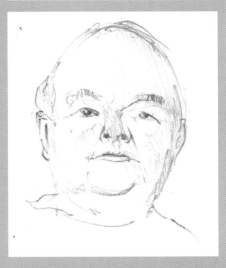

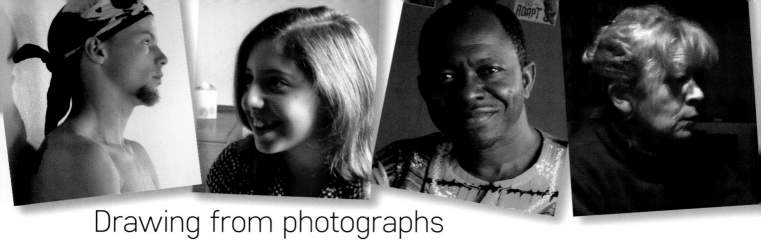

Drawing from photographs

There are many practical advantages to drawing from photographs. From the artist's point of view photographs don't move, and from the subject's point of view, they don't have to keep still. Less flippantly, it is not always possible to arrange for someone to sit, even for the few minutes that may be all that is needed for the portrait drawing. There is less pressure for the sitter (indeed none if the photograph is selected from several taken informally) and for the artist, who can work at his own pace.

The subtleties of colour, not always captured by a photograph, are not a concern in a monochrome subject; so drawing is an ideal way to practise your tonal work without the additional complication of colour. When drawing from photographs, tonal values can be altered as you see fit. Similarly, the background can be included, varied or omitted.

Gathering photographic reference

Social occasions such as parties or weddings can provide opportunities for informal shots that make great reference for portraits. However, lighting conditions in such situations may not be ideal for a good photograph. Naturally there is a relationship between the quality of the photograph and the quality of the resulting drawing. A photograph taken in poor light, or with poor definition, for example, will never lead to a highly finished and detailed drawing.

Fortunately, modern cameras, even some phone or tablet ones, can extract usable material from unpromising situations. In fact, almost any camera can be used to get source photographs for your portraits. The critical thing to develop is an eye for a good potential shot. From here, you can learn how to adapt to hindrances such as poor light or great distance. In these events being equipped with a camera that can be adjusted to increase its sensitivity is advisable.

Using reference for drawing portraits

When working from photographic reference, ensure that it is as clear as possible and that you get as much information and detail as possible about the subject. My camera's card, on which the pictures are stored, can be slotted into my computer. I sit astride my folding easel and draw and paint from a large high-definition screen. Alternatively, I can sit in my study and work from a large image produced by a digital projector. Both approaches give me ample information from the photographs.

You may prefer, or need, to work from prints of your photographs, in which case I recommend you get your pictures printed to at least 210 x 297mm (8¼ x 11½in).

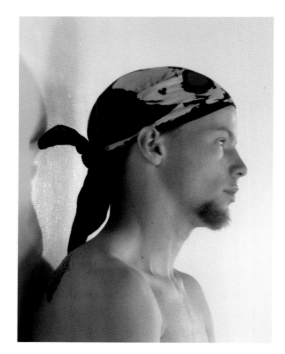

An example of a good photograph from which to draw. The light is clear, the sitter has been carefully composed, and everything that I want to include in the finished artwork is present.

The same source photograph can produce a simple or a painstaking drawing, depending on the client's requirements – or artist's preference. A portrait produced from this photograph can be seen on page 89.

Choosing a photograph

When choosing a photograph to use as reference for your drawing, look for a striking image. This could be a strong face, as in *Trefor* on page 39; strong contrast, as in *Terrence* on page 46; or unusual composition – the hands in the action of knitting add interest to an otherwise conventional pose in the charcoal drawing of Trish on page 47, for example.

Unlike charcoal drawing, a pencil drawing will not have the full range of tone from black to white available. This limitation can be put to advantage when faced with a photograph with significant dark areas where detail has disappeared. The pencil portrait can find detail in these dark areas. The following pages show some examples of pencil portraits alongside the photographic reference I used, and I examine some of the decisions I made in translating the photograph to a finished portrait.

Tip

If you are using digital images, increasing the brilliance level in the photograph can assist the discovery of additional detail in the darker tones.

Zoe

I always prefer working from my own photographs and this is one taken in my study. I had been commissioned to produce a drawing of Zoe and her sister, of which this was the more successful. In comparing the photograph to the result, you will notice I have omitted any background – often a distraction in a monochrome subject – and vignetted the image. This simply means that the detail in the portrait is kept in the centre, and gradually fades out to empty space at the edges, rather than being continued to the edge of the paper. This compositional choice is a good way of using a photograph that has an awkward crop that mean some minor details are missing from the edges.

The original photograph is a little blurry, but because the image captured Zoe's character so well, such a minor drawback could be ignored. There was sufficient information remaining to produce a pleasing result.

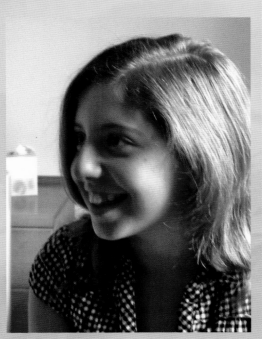

The source photograph.

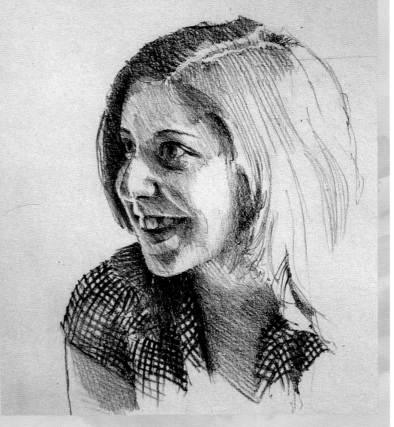

The finished drawn portrait.

Terrence

This studio photograph was supplied to me by the subject of it, and I was commissioned to produce a portrait drawing which would feature in his forthcoming book. In the event he used the photograph, though he assured me this was no reflection on the drawing. (I believed him, since he then commissioned an image for a book cover from me).

The photograph was of good quality, with the face and features clear and composed. In contrast to the photograph of Zoe on the previous page, the background here is blank and dark, with nothing in the way of distraction. The lighting, however, is a little stark, resulting in high tonal contrast. When producing the portrait drawing, I made sure to even out the light and dark tones a little, in order to ensure the detail was not lost.

Knowing that the resulting portrait had a specific purpose – as an author's picture – I changed the format from landscape to portrait, which made better use of the space. In changing the format, I made sure to keep the face central: a suitable choice for a formal portrait such as this.

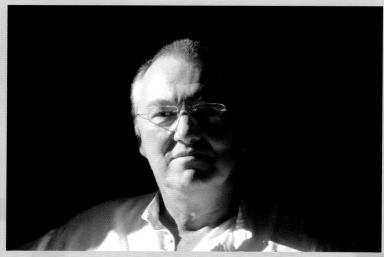

The source photograph.

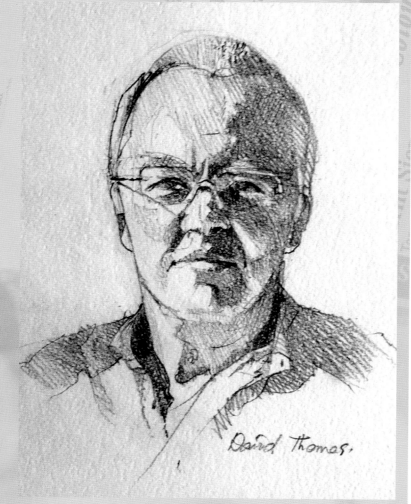

The finished drawn portrait.

Trish

A good subject for charcoal, because of large dark areas, which are not easily rendered in pencil. Although the figure is centrally placed, the symmetry is disturbed by the background treatment, and interest added by the hands and spectacles.

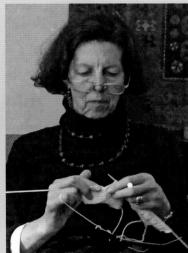

The source photograph.

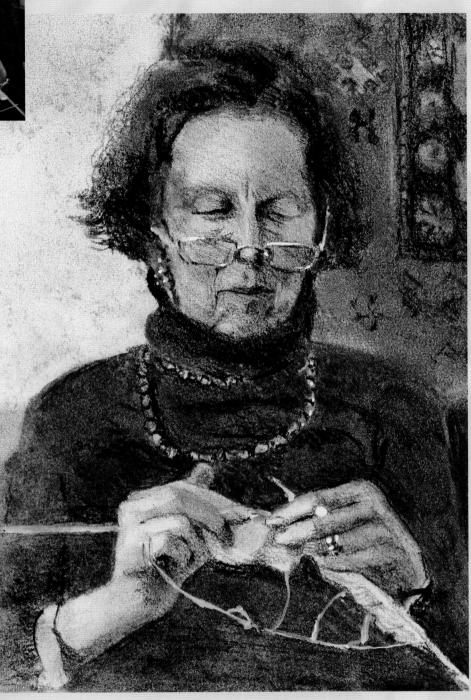

The finished drawn portrait.

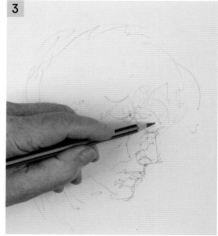

The source photograph.

Drawing with pencil

This short demonstration is intended to show you how to use some basic drawing techniques such as varying pressure and hatching to draw a simple portrait based on a photograph. It utilises just one graphite pencil – a tool with which we are almost certainly very familiar and comfortable. The pose and lighting are prompted by the reference photograph, so there is no need to worry about these elements; concentrate purely on drawing.

The finished portrait, on page 51, shows just how quickly a recognisable image of a person can be built up using just a single pencil and a small piece of paper. With no background to complicate it, and by making sure we made good decisions in choosing a photograph with a suitable format, pose and lighting, the result is simple but pleasing.

Basic lines and establishing the features

The pencil is used lightly for these initial marks as we 'feel our way' around the portrait. While the marks will be virtually invisible in the finished portrait, the likeness will gradually be refined and built up from these first marks, so it is important to get them right. You might like to think of them as the foundations of the finished work.

The first thing to do is to work out where the portrait will sit on the page, and we can use the information on composition and proportion (see pages 16–19 and 20–23 respectively) to help guide us.

You will need

38 x 56cm 15 x 22in) 96gsm (43lb) cartridge paper
6B pencil

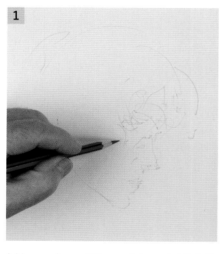

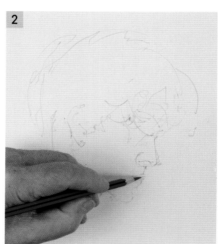

1 Use a sharp 6B pencil to establish the main shapes of the head and face. Place it slightly above halfway on the paper, leaving enough space for the shoulders. Keep the lines light and loose, suggesting only the mass of hair and the main structure of the nose, lips, chin and jawline.

2 Using the level of the eye and the hairline to help guide you, add the ear, then suggest the neckline. Begin to refine the nose using more considered marks and slightly more pressure.

3 Work carefully as you begin to refine the features of the face, using the initial lines to guide you as your strengthen the features. Use less pressure for areas such as the line of the cheek in order to keep these lines softer.

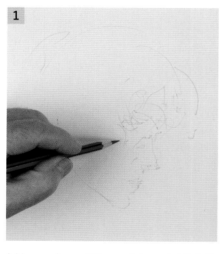

48

Developing the main features with initial tone

With the initial lines in place, we can begin to refine the features to develop the likeness, and extend the body into a full portrait.

Secondly, we begin to introduce tonal work by varying the pressure, and using a technique called hatching.

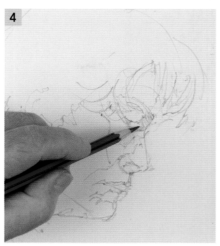

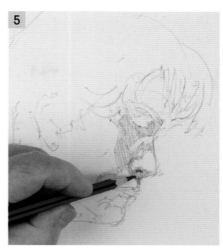

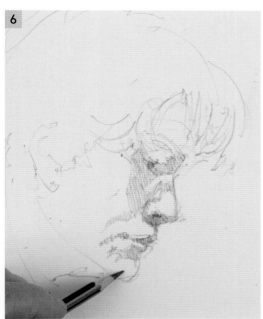

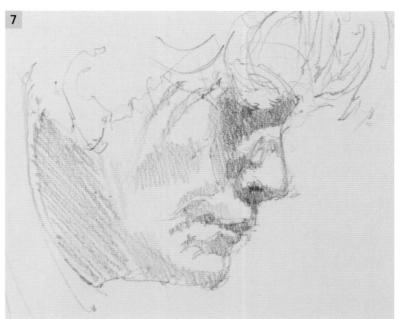

4 Using a light zigzagging motion, begin to add in larger areas of shading to establish the tone. This zigzagging technique is known as 'hatching'. Start below the brow.

5 Continue to build up the tone in the shaded areas with the hatching technique. For darker tones, such as below the nose and lips, use more pressure and keep the zigzags closer together. For very dark tones such as the nostril, keep the zigzags very close indeed and use even more pressure.

6 Continue to work down the face, leaving areas of highlight such as the top of the nose and upper lip clean. Work carefully around the mouth to get the variety of tone necessary to evoke the expression of the sitter.

7 Away from the main features, work slightly more freely to add in the light tone on the neck and cheek. Referring closely to the reference picture, you can strengthen tones further by working additional layers of hatching over the same areas. This is a good way to gradually build up the depth required without working too dark too quickly.

Framing the face

With the basic tones on the important features on the right-hand side of the face in place, it is now time to develop the rest of the portrait; areas such as the hair, clothing and neck. The darker tones you have established on the features on the right-hand side can be used as reference when placing the lighter tones on the rest of the head. The contrast between the light midtones here and the very lightest tones in the highlight areas are subtle, but enough tonal work must be done in the midtones to ensure the clean paper reserved as highlights stands out as different.

The clothing is secondary to the face in this simple portrait, but it plays an important framing role, so the tonal work must be correct. A loose treatment ensures that the eye is not drawn from the face by too much detail in the sweater, but a balance must be struck between speed of work and neatness.

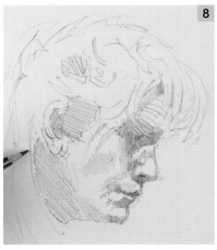

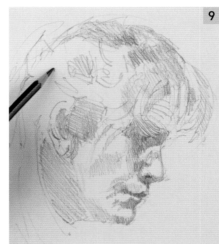

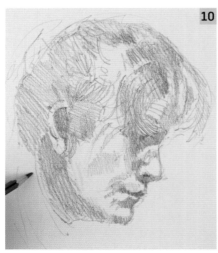

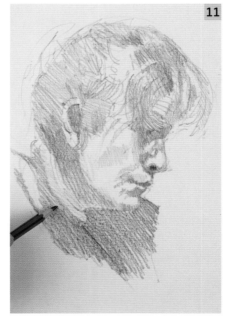

8 Develop the tone on and around the ear using the hatching technique. Add a few loose strokes in the hair where the source photograph has obvious curls, waves or other textures. You are aiming simply to suggest the texture of the hair as a whole, so do not obsess over each individual filament.

9 Using the fine lines to help guide you, develop the tone in the hair. The tones here should not be as strong as in the features of the face as the hair is in the light, and casting some of the shadows onto the face. Refer to the source photograph every so often to make sure that you are placing the areas of tones correctly in what can be a complex area.

10 Continue to build up the tone in the hair, paying atention to the way the light falls. Broadly speaking, the tones will be lighter in the centre of the head, and darker towards the sides. Use longer strokes to suggest the more obvious shape of the fringe where it falls away from the head over the sitter's eyes.

11 Add the line of the shoulders and develop the tone of the sweater with strong hatching. This area of dark tone contrasts well with the lightness of the skin around the chin, creating counterchange.

Finishing the portrait

The final stages are very important in ensuring a likeness, and hours can be spent in tidying and refining the portrait. However, the underlying principles are relatively simple – you pay close attention to your reference photograph and gradually refine the work on your paper.

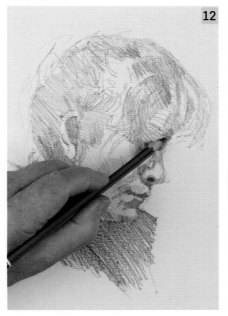

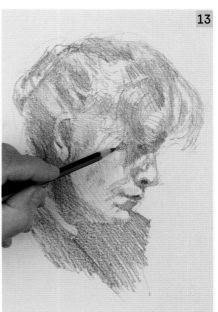

12 With the tone being developed sufficiently to frame the features and partially obscure the initial lines, you are close to the end of the process. Return to the main focal areas (the features on the right) and evaluate the tones here. Use further layers of hatching to strengthen the tone where necessary.

13 Refine the tone across the whole portrait with gradual layers of hatching, working increasingly more lightly to build up a realistic finish. Be careful not to overwork the portrait, and be sure to retain lighter tones, particularly in the areas of highlight such as the upper cheek and centre of the hair.

14 Make any final adjustments and refinements to finish.

The finished portrait

When selecting a medium for a portrait, pencils tend to lend themselves to relatively clear, light tones, as pencil is a medium best suited for line rather than deep tone. That said, they can produce deep tones when required using strong dense hatching and repeated layers, as demonstrated here.

Compare this with the watercolour version on page 24 and the charcoal version on page 57 to see the differences the choice of medium can make, and how each one draws out different subtleties from the source photograph.

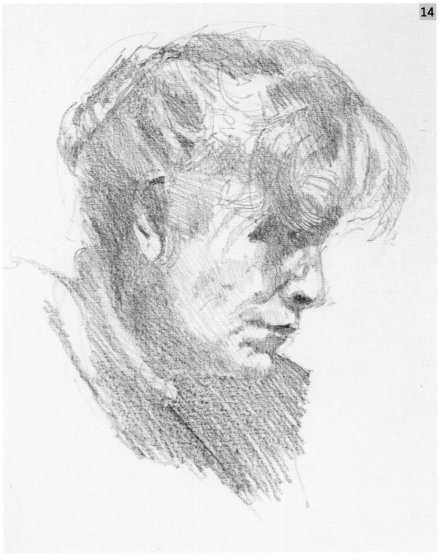

Using charcoal

Unlike graphite pencil, it is possible that you have never used charcoal, which is a wonderful medium for portraiture. It lends itself to strong tonal contrast, which can give very effective results for your portraits.

 The following pages cover some basic techniques for using charcoal, some of which are shared with the pencil techniques covered in the short project on pages 48–51, and some of which, such as lifting out, share some similarity with the watercolour techniques covered later (see pages 60–67). For this reason, charcoal is an instructive transitional medium for your portraits, and also a very valid one in its own right.

1

2

3

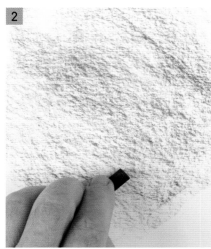

4

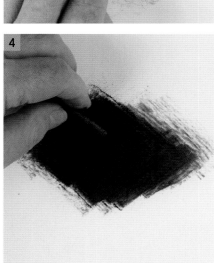

Laying in

1 Snap a thick stick of charcoal so you have enough to grip.

2 Holding the stick flat on the surface, rub the stick across the surface to lay in a flat area of charcoal.

3 Using more pressure will result in a darker tone.

4 To deepen the tone still further, repeat the process at another angle.

Tip

You may find it easier to move the paper than to work the charcoal at an uncomfortable angle.

Hatching and softening

1 Lay the stick fairly flat and zig-zig the end of the charcoal over a small area.

2 Use your fingers to smudge the colour into the surface.

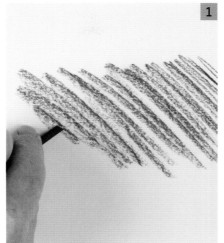
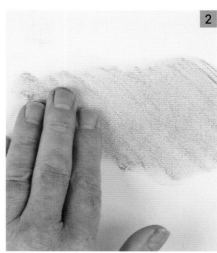

Lifting out

1 An eraser can be used to lift out some white paper. This technique is useful for adding highlights.

2 This works even on very dark tones. More control can be achieved by cutting the eraser into a point using a craft knife. This allows you to work in finer detail.

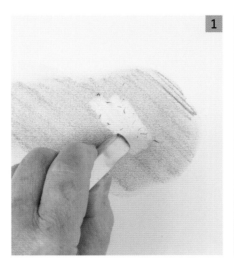
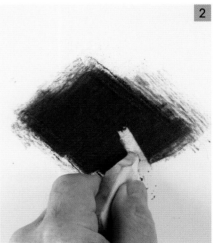

Working with charcoal pencils

1 For areas of fine detail, a stick may not provide enough control. Here, a charcoal pencil can be used to excellent effect. Use it exactly as you would a pencil, allowing you to add fine lines. Add more pressure for darker tones, and reduce it for lighter tones.

2 Continue building up the drawing until you are satisfied.

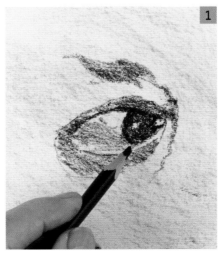
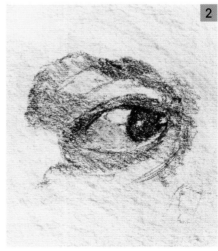

Drawing with charcoal

Like the earlier graphite pencil demonstration on pages 48–51, the project on the following pages will show you how to use charcoal to create a quick portrait with great tonal contrast. I have deliberately used the same source photograph so that you can compare the finished results in different media.

If a charcoal portrait is to be undertaken, check your reference photograph shows high contrast in order to make the most of the medium. This photograph shows the head clearly, and includes the full range of tones, allowing me to produce a drawing that will range from the white of the paper to the densest charcoal application. There is sufficient interest in the subject to make a plain but graded background all that is required.

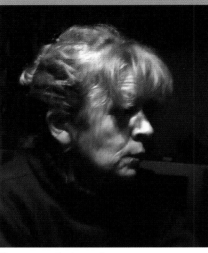

The source photograph.

Basic lines and background

This portrait begins in exactly the same way as using graphite pencil; by positioning the portrait on the page with light marks in order to feel our way around the portrait. As before, because we have the original photograph from which to work, we can use this as a guide for the pose and lighting.

You will need

38 x 56cm (15 x 22in) 640gsm (300lb) hot-pressed watercolour paper
6B medium charcoal pencil
Willow charcoal stick
Craft knife and eraser

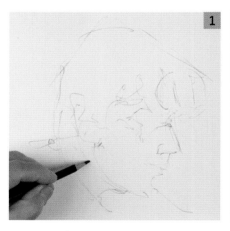

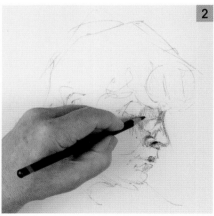

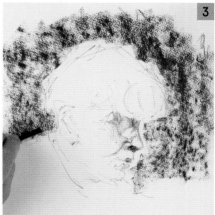

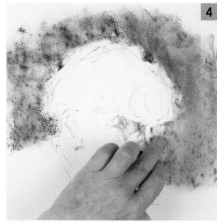

1 Use a 6B charcoal pencil to draw the basic shapes of the portraits on the wrong side of the hot-pressed paper. Do not add any tonal work. Restrict yourself to light lines which demarcate the essential features and shape of the head and body.

2 Still using the charcoal pencil, refine the features and add some dark tone around the features, particularly the brow, nose and lips. Use the hatching technique (see page 53) to develop some midtones around the right-hand side of the face exactly as though using a graphite pencil.

3 Using the edge of a piece of willow charcoal, lay in a light layer of charcoal across the background, avoiding the outline of the head and body.

4 Smudge the charcoal into the surface with small circular motions of your fingertips.

Developing tone

The midtone on the background provides a good starting point for adding darker tones. The white of the paper is reserved for the lighter tints and highlights.

5 Use the charcoal pencil to add in darker tone to bridge the gap between the background and the edge of the face. The willow charcoal is too imprecise to allow you sufficient control to work right up to the face without risking smudging across it.

6 Smudge the charcoal pencil in with a finger to blend the dark tone into the background, then build up the tones in the features on the right-hand side of the face using the 6B charcoal pencil and the hatching technique. As with the graphite pencil, the charcoal pencil allows you enough control to leave areas of clean paper, reserving them for highlights.

7 Still using the charcoal pencil, establish the areas of darkest tone in the ear and hair on the left-hand side. Use the side of the willow charcoal to lay in an area of midtone on the hair.

8 Soften in the midtone on the hair. Using the end of the willow charcoal, begin to block in the dark tones under the jaw and around the ear. You can use a little more pressure, but you do not need a lot to create dark tone with charcoal.

9 Soften in the area, then use the tip of the charcoal much more lightly to add some controlled areas of softer tone around the ear and across the cheek. Again, soften them in with small motions of the finger.

10 Still using the tip of the willow charcoal, overlay the dark area of background to the right of the face, and smudge it in to further blend the area into the background.

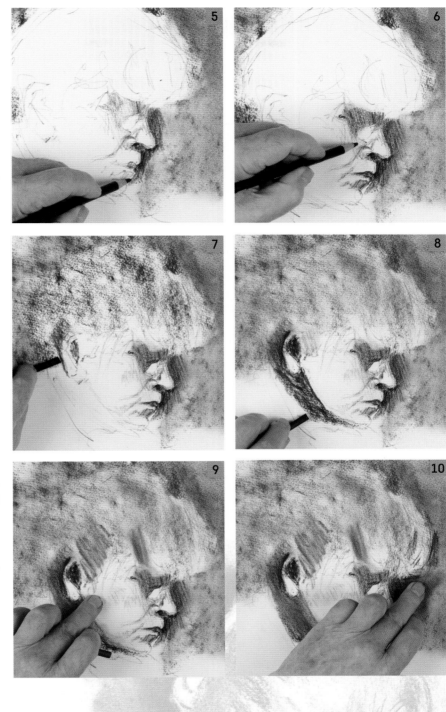

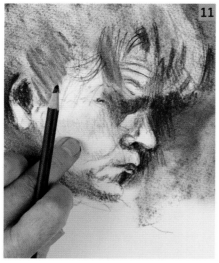

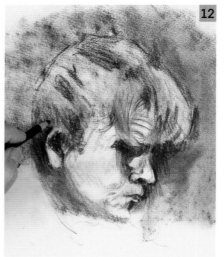

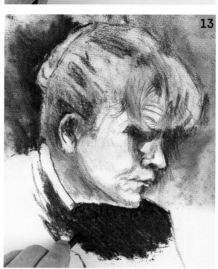

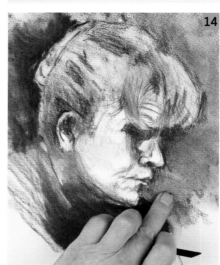

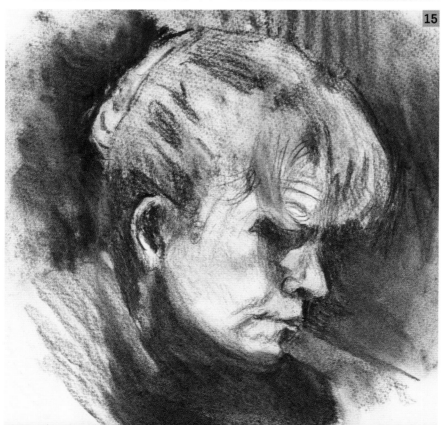

Refining and framing

The dark clothing and background make use of charcoal's depth of tone, and so careful refinement is necessary to ensure the face retains its detail.

11 Change to the charcoal pencil to develop the tone in the hair above the features, particularly around the fringe. Use the tip of the pencil to add sharper details like the wrinkles on the brow and around the lips. Working lightly, add some soft tone to the cheek, too. Use a finger to blend the shadows into the cheek a little.

12 Continue to refine and adjust the areas of tone across the face and hair with the charcoal pencil, softening in the marks with your finger. Pay careful attention to your reference image as you strengthen the tone with further layers of charcoal pencil. Be careful to leave the areas of highlight clean, and pay careful attention to getting the subtle midtones correct in relation to the shades.

13 Use the end of the willow charcoal to strengthen the background behind the head (i.e. on the left-hand side of the portrait) and blend it away into the background. Next, use the end of the willow charcoal to draw in the outline of the sweater and establish a very dark tone across it.

14 Soften the charcoal in on the sweater, then use the dark tone as reference to strengthen the tone in the background on the right of the face. Keep the area slightly lighter than the sweater so that the two areas are distinguishable.

15 Continue to refine and strengthen the background to create the tonal contrast which lends finished charcoal works their distinctive dramatic result.

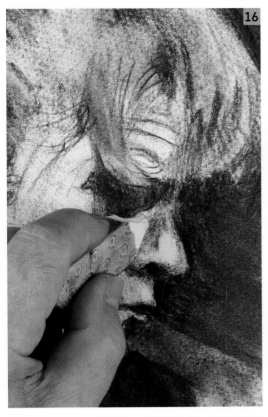

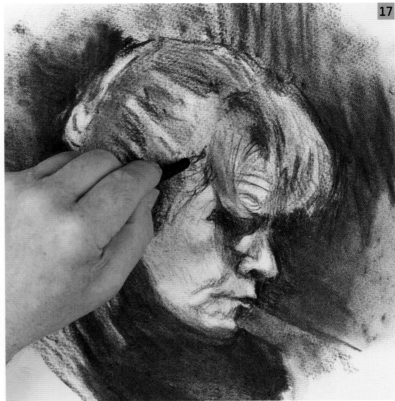

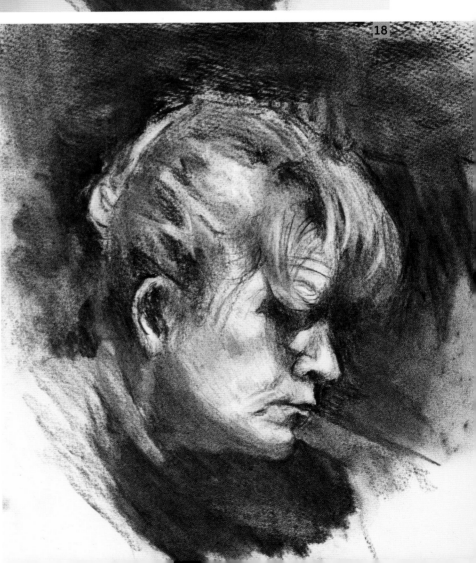

Tip

If you decide any areas have become too dark, you can use a plastic eraser to rub away some charcoal and lighten the tone.

Final adjustments

Any alterations at this point are minor but important. Spend time studying your reference photograph before you make adjustments.

16 Use a craft knife to trim your eraser to a point (see page 53) and use the point to lift out any sharp highlights, such as on the top of the lip and on the nose.

17 Use the tip of the willow charcoal to refine the details across the whole portrait, gradually tidying and tightening the image.

18 Make any final refinements to finish.

The finished portrait

Compare and contrast this charcoal rendition of the portrait with the pencil version on page 51. A photograph can produce different results – it is down to the artist to bring out the potential in each one.

Using watercolour

This chapter is to help the reader with the perhaps daunting prospect of picking up a brush and producing a watercolour portrait. It begins with a series of practical exercises dealing with the essential techniques needed for watercolour painting. Previous chapters have focussed on tonal media, such as pencil and charcoal. With the introduction of colour we enter a new world, full of new challenges and opportunities. We must not lose sight, however, of what we have learned about tone, and the section on colour and tone (see page 68–71) shows how these two aspects are combined when we paint. We must be able to judge tone when applying colour. The section continues with suggestions about colour choices, the colour wheel and colour relationships.

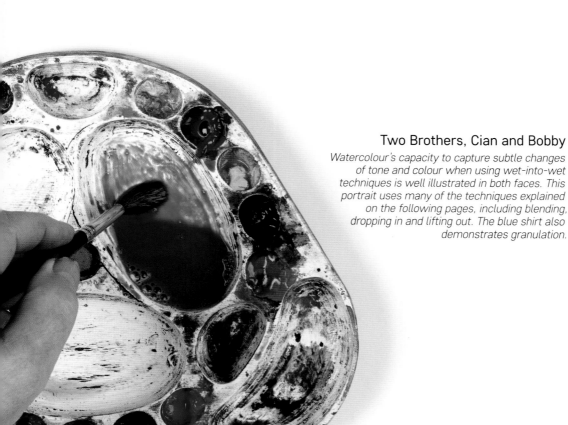

Two Brothers, Cian and Bobby
Watercolour's capacity to capture subtle changes of tone and colour when using wet-into-wet techniques is well illustrated in both faces. This portrait uses many of the techniques explained on the following pages, including blending, dropping in and lifting out. The blue shirt also demonstrates granulation.

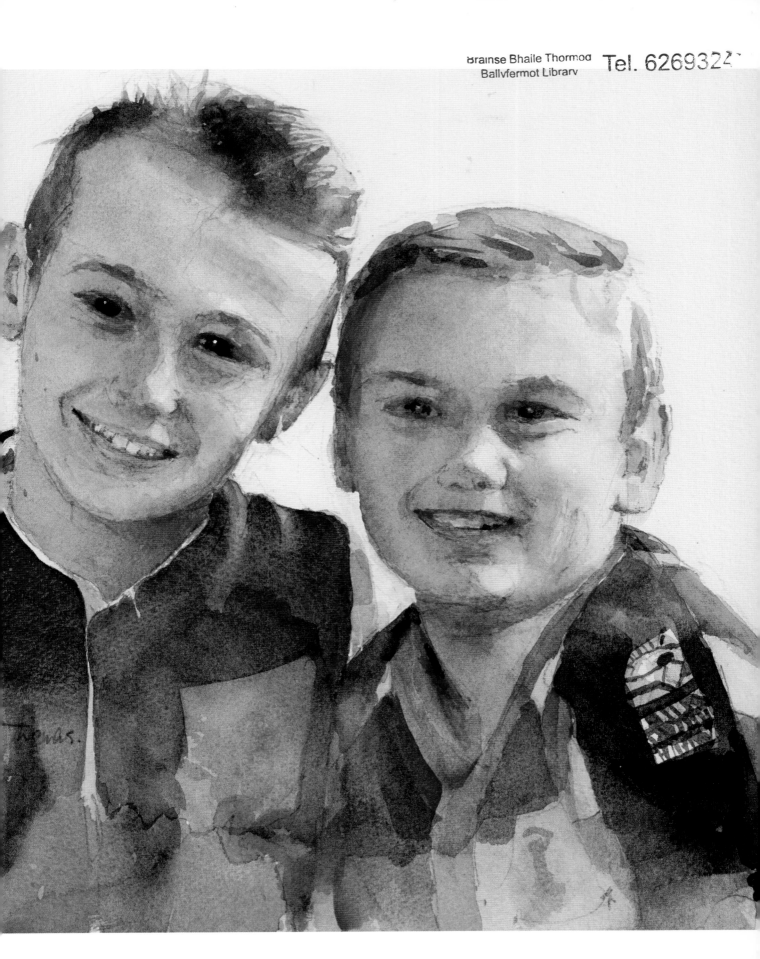

Watercolour painting techniques

Whether you intend to paint portraits, landscapes or anything else, all watercolourists should become familiar with three basic techniques: the wash, the glaze and wet-into-wet.

The exercises on the following pages are intended to show you how to use your paints in the most fundamental manner, as this is the best way to learn the unique qualities of watercolour. Besides this, the exercises are both instructive and fun to try out.

Before you begin, you will need to get your painting area ready and prepare your watercolour paints.

Preparing to paint

Before you begin, set up your easel and set your board at an angle roughly thirty degrees off horizontal. This is steeper than the angle normally used in order to encourage the washes to flow. Use masking tape to secure a sheet of 300gsm (140lb) watercolour paper, at least 56 x 38cm (22 x 15in) in size, to the board. It is important to keep your water clean throughout. As you work, replace the paper and refresh your water pot as necessary.

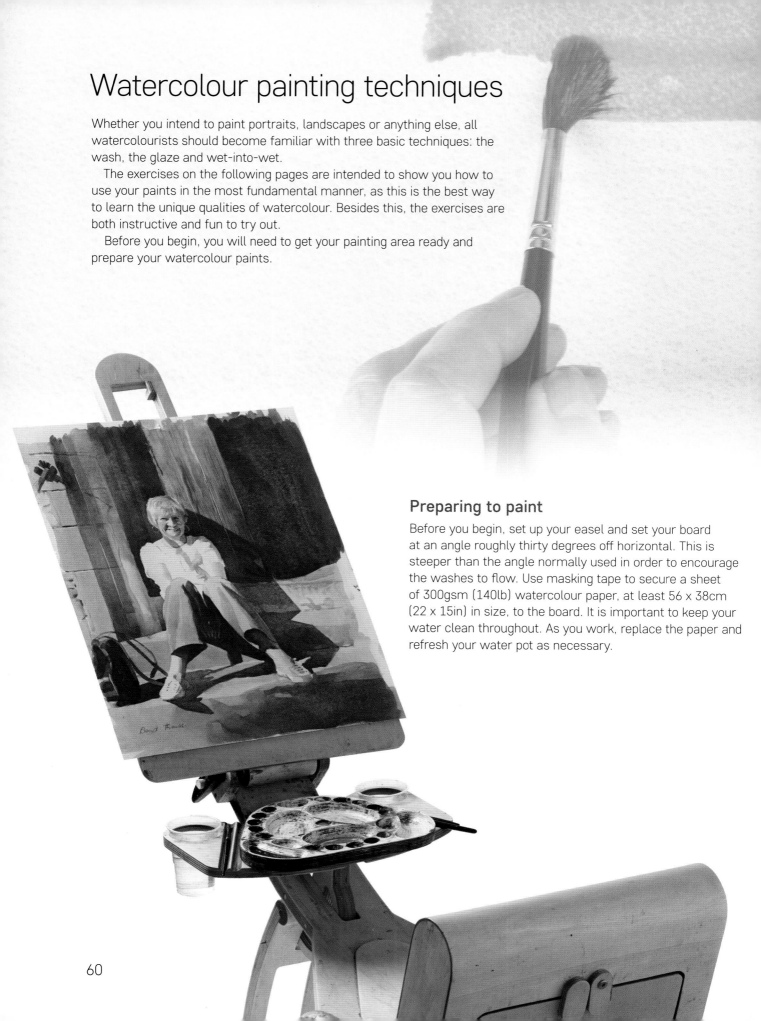

Preparing watercolour paint

Paints squeezed from a tube into your palette will harden after a time, so prepare them fresh each time. If they have hardened, you can refresh them by running the palette under hot water briefly, and letting the pigments soften for a few minutes. The brush will then pick up colour without the need to vigorously push it into the paint, which risks damaging the hairs.

Tip

If you are unsure of the amount of paint you will need, it is almost always better to err on the side of generosity. A little paint left over is preferable to running out halfway through a wash!

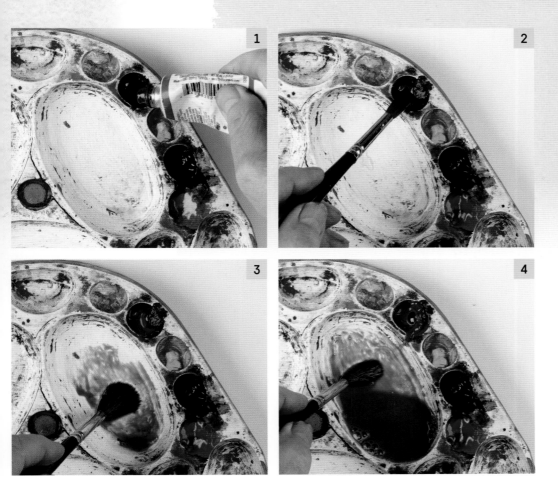

1 Squeeze a small amount of paint into the well.

2 Add some clean water into the palette well using a brush, then dip the damp brush into the paint.

3 Bring the paint over to the well and combine the paint with the water.

4 Repeat the process to build up the required amount of prepared paint in the palette well.

Flat wash on wet paper

This first exercise shows you how to achieve a flat, even layer of colour on your board, by 'washing' the colour over the paper in a controlled way. Before you begin, prepare a fair amount of paint, as described on page 61. I have opted for a viridian green for clarity, but you can use any colour you choose.

1 Use a large hake brush to wet the paper area with clean water. Use broad horizontal strokes to lay on a generous, even layer of water.

2 Still using the hake brush, pick up some paint from your well, and draw a single stroke across the paper.

3 Refill the brush with paint and repeat the process slightly further down the paper, drawing the brush horizontally across the paper and overlapping the bottom of the previous brushstroke.

4 Repeat this down to the bottom of the paper.

5 Allow to dry naturally, and do not be tempted to touch the surface or fiddle, as this will cause obvious marks in the finished wash.

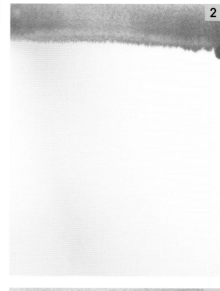

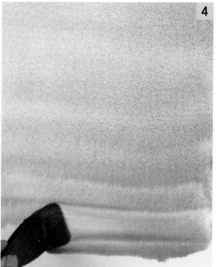

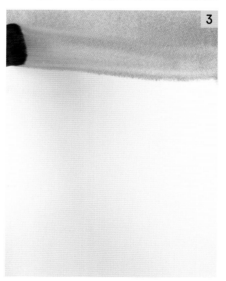

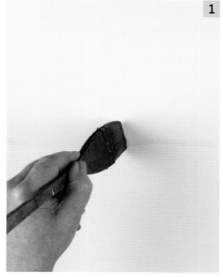

Flat washes on wet paper should result in paper covered evenly with the wash, as shown here. Note how much lighter the colour is in the dry result than in the wet paint shown in the steps above. Remembering this quality is of fundamental importance when applying washes in watercolour – the result will look very different when dry.

Unlike glazing and wet-into-wet (see pages 64–65), this technique rarely has a direct application in portraiture, where large areas of even colour or tone are uncommon. Its value is in making you familiar with two characteristics of watercolour: the difference between placing paint onto wet paper and onto dry paper, and the way in which the colour lightens as the paint dries.

Flat wash on dry paper

Dry paper can make it slightly harder to achieve a flat, even tone with a wash. Nevertheless, it is possible, and the result is typically much stronger and more vibrant than with a wet wash, as the colour does not lighten as much as it dries.

1 As before, prepare a large amount of paint, but begin work onto a dry surface; applying the paint with horizontal strokes of a large hake brush.

2 Continue working down with horizontal strokes that overlap the previous stroke. You may find that the paint will not quite reach to the end, resulting in the broken effect shown.

3 To cover this and ensure an even result, ensure the following strokes cover any missing area while the paint is drying. However, do work quickly, and try not to go back to areas if possible. You may well find that the paint drips down the page. Do not panic – you will cover this smoothly as you work down the page as normal.

4 Work down to the bottom of the page as before.

5 Allow to dry. Compare the result with the wash laid on wet paper (see opposite).

As on wet paper, washes on dry paper should result in a flat, even colour. In particular, note how the streak caused by the drip is almost unnoticeable in the finished result, as is the broken line shown in step 2. This is achieved by working confidently and quickly, and sticking to the strong, unvarying horizontal strokes.

You will likely have found it more difficult to obtain a smooth finish when working on dry paper than with wet, because the clean water helps to diffuse the paint evenly. However, do persevere until you can effortlessly produce a flat, even result on both wet and dry paper. Any expense incurred by the use of paper is well worth the experience you gain.

Any difficulties encountered in painting on dry paper are made up for by the strength and vibrancy of the result. Compare the resulting colour of the wash on dry paper with that on wet paper.

Glazing

Washes are applied to clean paper, glazes are applied over other washes to darken the tone, or alter the underlying colour. Glazes are useful for building up subtle skin tones.

Using any reasonably-sized brush lay in a flat wash on one of the dry sheets from the wash exercises (see pages 62–63).

1 Use the brush to lay a second wash over the top of the first, in exactly the same way as before.

2 Work down to cover the area and then take your brush away.

3 While wet, compare the glazed area with the underlying layer of colour (left of picture), and allow the paint to dry.

4 As the paint dries, the effect will be reduced, but it will still be clear where the glaze has been laid.

In this detail from Father and Son, *you can see how the colour and tone have been built up in the skin of both figures through repeated glazes. The full painting can be seen on page 113.*

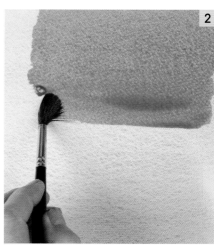

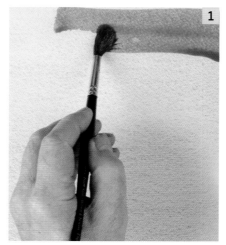

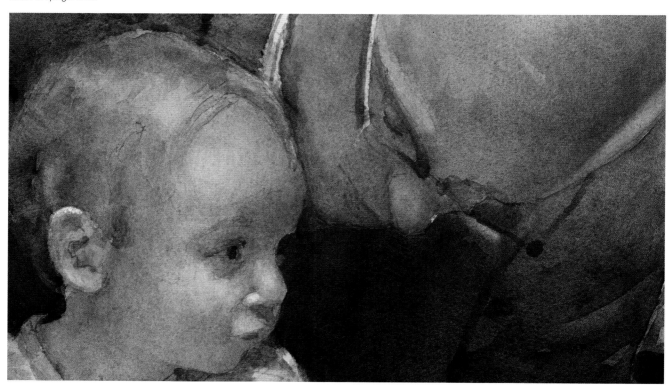

Wet-into-wet: blending

The wet-into-wet technique is what distinguishes watercolour from other media and produces excitement for both the artist and the viewer.

Becoming a competent watercolourist is closely linked to learning how to control and exploit this facet of the medium.

1 Prepare two large wells of different colours. Lay in a wash of your first colour down to halfway down the paper, then quickly turn the paper through one hundred and eighty degrees and begin to lay in your second colour, working down from the top towards the previous colour.

2 Make one final stroke that brings the second colour down level with the first, so that the two areas of colour meet. Put the brush down and lay the board flat.

3 Allow the colours to blend and interact. The blending will continue until the paint dries. This allows you to mix colours on the paper, rather than on the palette.

Wet-into-wet: dropping in

1 Lay in a wash of one colour. Quickly set the board flat and load a brush with a different colour. Touch the loaded brush to the wash while it remains wet.

2 Lift the brush away and let the colours merge into one another. As with wet-into-wet, the colour will continue to move until the paint is dry.

Other useful techniques

In addition to the core techniques of wash, glaze and wet-into-wet, the following techniques are a useful addition to your repertoire.

Lifting out

This is a very useful watercolour technique for creating gentle highlights on skin, as on the head of *Geoff* on page 83; or hair, as with the eyebrows of *Dr Alan Kelly* on page 85. Such highlights could have been created by painting around the area, but this method gives a softer and more subtle result.

More absorbent papers will not allow so much colour to be removed as those that are more heavily sized.

1 Wet a flat brush and use the edge of the tip to agitate the surface and re-wet the paint.

2 While wet, press kitchen paper or a sponge on to the surface to lift away the re-wetted colour.

3 This can be used even when the paint has been applied in layers.

4 For large areas, you can use a damp household sponge to scrub the surface. More vigorous scrubbing will allow you to get back closer to the paper surface.

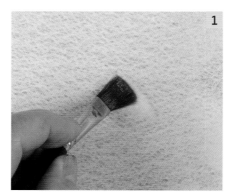

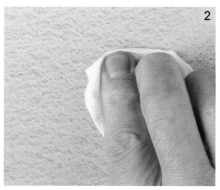

Tip

The paper you use is important when lifting off paint. Different manufacturers' papers – even those of the same weight and surface – will have different qualities that may affect how you can lift off paint, both how much and how easily.

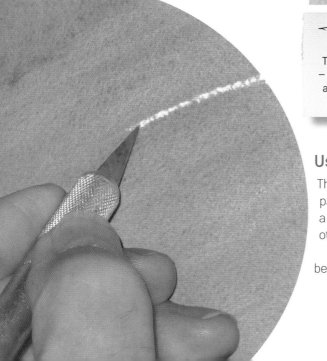

Using a knife

The tip of a craft knife can be used to gently scrape away the surface of the paper. When used on a painted surface, as shown to the left, this reveals a white mark of clean paper. This is a good way of indicating single hairs or other fine marks.

A highlight in the eye can be created with this method, but generally it is better to simply avoid the area when painting.

Adding white: masking fluid

Masking fluid can be used to reserve the paper surface, keeping it clean while you paint over the area. If it is necessary to create thin white lines, as seen in a head of grey hair or a beard, this is a good method.

1 Use an old brush to apply the masking fluid to the areas of your paper you wish to remain white. Once it has dried, paint over it as normal and allow the paint to dry. Use a clean finger to begin gently rubbing the masking fluid away from the surface.

2 Continue rubbing away the masking fluid until it has all gone. The clean paper will be revealed beneath. This can either be left clean – which is excellent for stark highlights – or you can continue to paint over the area.

Adding white: ink

Applied with a fine brush, white ink can achieve a similar result as masking fluid, making it useful for fine white lines.

Granulation

You may have noticed an effect called granulation occurring in washes of French ultramarine or other granulating colours. This is a natural result of the pigment settling out of the solution into the valleys of the paper. Proprietary solutions can be added to other non-granulating colours to induce this effect. This is watercolour's gentle challenge to oil, whose pigments can be applied in thick layers (impasto) to create a genuine third dimension.

While the effect is not usually appropriate for skin, it can be useful to add interest to portrait backgrounds, as in *Morydd* (see page 1), *Elderly Gentleman* (see page 25) and *The Last Suppers* (see pages 28–29).

Backruns

Make sure that the surface is not merely damp when applying more paint, or the wet second colour will meet the drying first colour and push the damp paint unevenly, resulting in an unwanted backrun or 'cauliflower'.

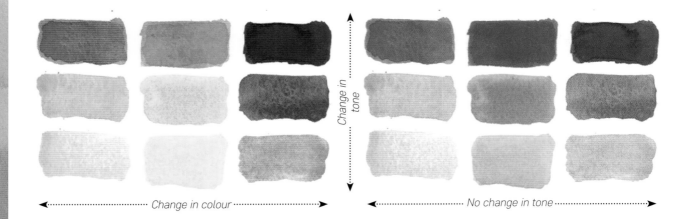

Change in tone

Change in colour　　　*No change in tone*

Colour and tone

Many books have been written about colour, and it is beyond the scope of this one to go into it in any depth. I have deliberately avoided using words like value, hue and saturation because their definitions vary even among experts. I doubt if even acknowledged masters such as the Impressionist artists Monet and Degas were fully conversant with the theory of the subject, and if they did not need to be, neither do we.

Light and colour

We see the world in colour – as long as there is light. The less light, the less intense are the colours we see. Watercolours are made less intense by adding water, which also lightens their tone. Artists must be aware of a colour's tone, because without tonal variation a painting will lack impact.

Tone and colour

Most paintings do make use of a wide range of colour tones, and good ones will invariably work well in a monochrome version. It is possible to separate tone and colour, as in the coloured drawing, where all the tone has been created by the pencil, and colour washes of similar tone have been applied over the top. However, as painters, we usually have to deal with tone and colour simultaneously.

The diagram above is split into two parts. The left-hand side shows swatches of dark, medium and light tones of three different colour paints, while the right-hand side shows the same swatches with the colour removed, leaving only shades of grey. Note how close the different paints are in tonal value when we remove the colour.

If we were to create a painting which used only the colours from any one horizontal line, it would have no tonal variation and, as a result, lack impact. Converted to a black and white image it would be a uniform grey – light or dark according to which line was chosen.

For this reason, make sure your portraits include a variety of tones.

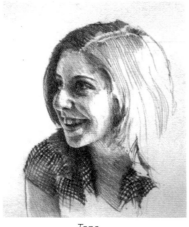

Tone

Colour

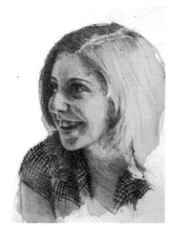

Colour and tone

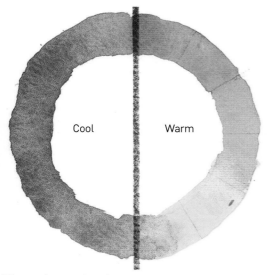

The colour wheel

The colour wheel is a visual tool for seeing the relationships between colours. The three primary colours of red, yellow and blue are set equidistantly around a circle, and are then mixed, producing the secondary colours purple, green and orange between them. I have divided the colour wheel shown here into the cooler blues and warmer reds.

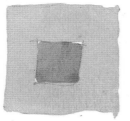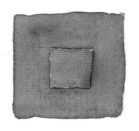

Warm or cool?

These identically coloured inner squares are made to appear cooler when set against a warm background (above left), and warmer when set against a cool one (above right).

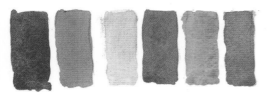

Complementary colour pairings

The complementary of blue is orange, of yellow is violet; and of red is green. Each pair sits opposite one another on the colour wheel.

Colour and paint

We rarely see unmodified areas of colour in nature – perhaps a green field or a bed of daffodils bathed in sunlight. But more often our perception of what we know to be green or yellow is altered by shadow, by failing light or by the effect of adjoining colours. The human face is just as subject to these effects as the landscape, and we must always be looking for them if our portraits are to convince the viewer.

As illustrated opposite, it is tone, not colour, which allows us to see the world in three dimensions; but the world, and our portraits, would be duller without colour.

In watercolour, the tone of a particular colour of paint is controlled by how much water is used in the mix – more water makes the tone lighter. The diagrams on this page help to explain the two other aspects of colour with which we need to become familiar: temperature and colour relationships.

Temperature

The colour wheel can be divided into two groups: warm and cool. In landscape painting, this is often exploited by using cool colours in the distance and warm colours in the foreground, creating aerial perspective. In portraiture, however, we can find warm and cool colours in a single face. Sometimes it is not clear if a particular colour is warm or cool, because the colour surrounding it affects our perceptions, as shown to the left.

Relationships

Colours relate to each other and are affected by each other. Complementary colours are those opposite each other on the colour wheel. So the complementary colour of blue is orange, for example. As black placed next to white is the greatest tonal contrast possible, so two complementaries placed side by side produce the greatest colour contrast.

Contrasts

Colour contrasts can be more subtle than the clash of complementaries. Here a cadmium red square is surrounded firstly by a neutral grey (left) and an intense yellow (right). The red stands out more against the neutral grey than against the yellow.

Colour choices

My palette, shown below, is based on the colour wheel concept explained on the previous page. It has a section for each of the three primary colour groups. My present choices are shown, but every artist will have their own selection, which will probably change or be added to over the years.

As mentioned earlier, it is quite possible to mix almost any colour you might need from just six pigments – two reds, two yellows and two blues, and my suggestions for this minimalist approach are: cadmium red and quinacridone violet; cadmium yellow and new gamboge yellow; French ultramarine and cerulean blue.

They should each have a bias towards the primary colour adjoining: for instance French ultramarine has a red bias, cerulean blue a yellow bias; so French ultramarine is placed closer to the red group in the palette. There are very many alternatives to these. I would recommend this system to any less experienced painter, because with so few colours you will soon become proficient at mixing, and less likely to create mud!

Colour temperature pairings in my chosen palette

- *Cadmium red (warm red; yellow bias) and quinacridone violet (cool red; blue bias)*
- *New gamboge yellow (warm yellow; red bias) and cadmium yellow (cool yellow; blue bias)*
- *French ultramarine (warm blue; red bias) and cerulean blue (cool blue; yellow bias)*

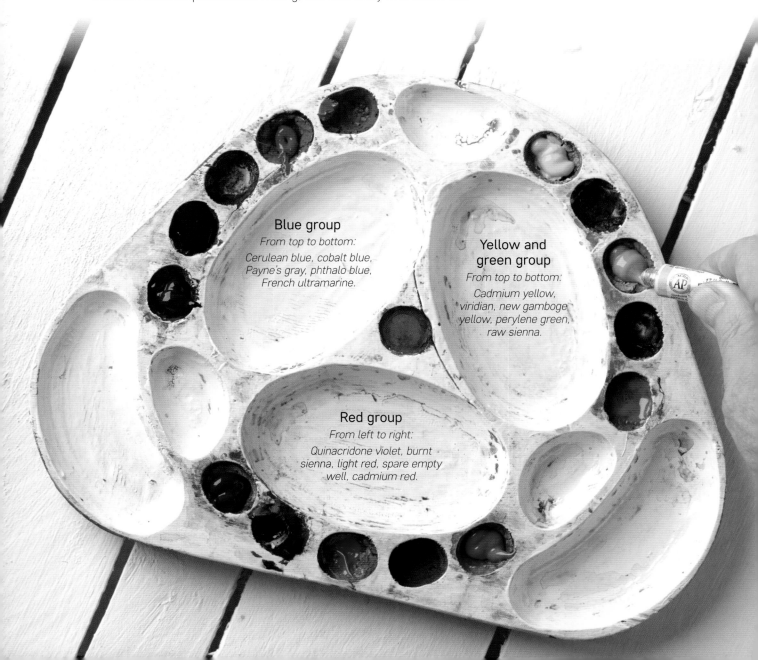

Blue group
From top to bottom:

Cerulean blue, cobalt blue, Payne's gray, phthalo blue, French ultramarine.

Yellow and green group
From top to bottom:

Cadmium yellow, viridian, new gamboge yellow, perylene green, raw sienna.

Red group
From left to right:

Quinacridone violet, burnt sienna, light red, spare empty well, cadmium red.

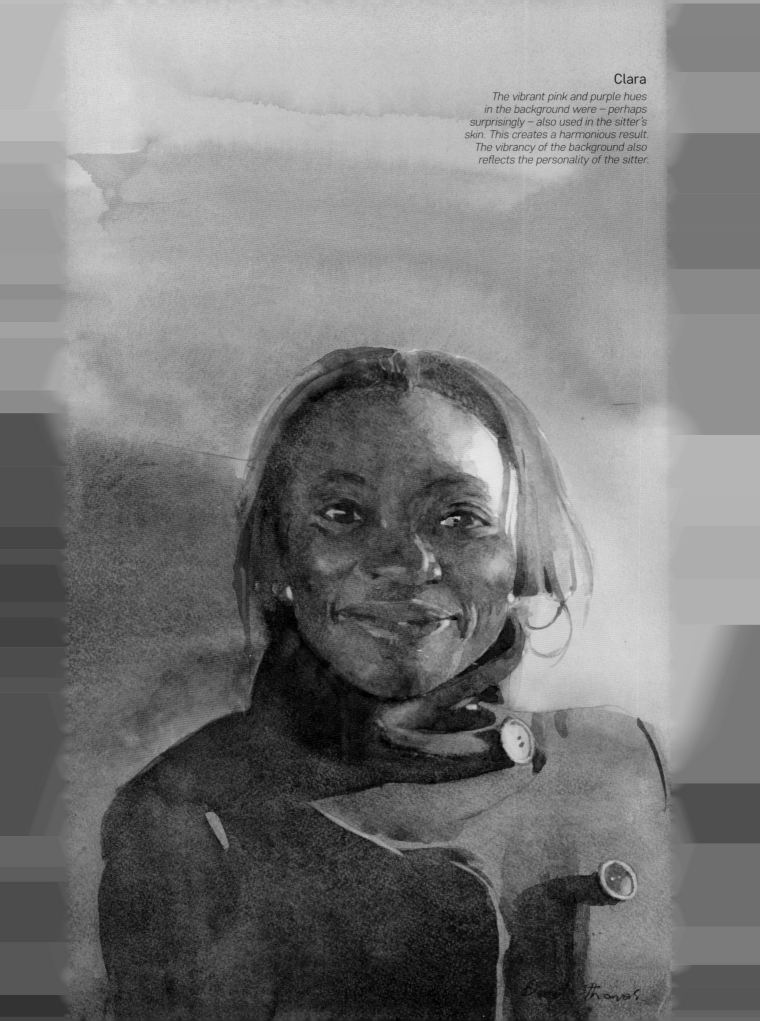

Clara

The vibrant pink and purple hues in the background were – perhaps surprisingly – also used in the sitter's skin. This creates a harmonious result. The vibrancy of the background also reflects the personality of the sitter.

Painting from life

In landscape painting there is often a conflict in the artist's mind between wishing to claim the authenticity and liveliness that comes from painting *en plein air* and the desire for control that he can achieve in his studio. This is paralleled in the portrait artist's desire to follow a great tradition which advocates painting portraits from life, and an equally laudable desire to produce studio quality work.

There is no doubt that meeting and getting to know the subject is the best beginning to any portrait, even if the intention is to eventually work from photographs. Even a brief acquaintance will allow you to know if you have caught a true likeness when painting. For most amateur painters, painting from life will mean a portrait or a life class, with the proscribed conditions this entails: limited choice of position, limited communication with the model, and limited time. They will discover that it is more difficult to paint well in these surroundings than it is from a photograph at home or in the studio. Nevertheless there is great satisfaction in meeting these challenges and making a piece of work that has spontaneity, and will always remind you of the time and place where you created it. My *plein air* landscapes affect me in the same way – they are not so technically accomplished as my studio work, but they often have an emotional residue.

Life drawing
While this is not strictly a portrait, the skills learnt at life drawing classes can provide excellent practice for portraiture – not least in honing your skills at quickly identifying the critical parts to capture.

Workshop model
A quick study of a model made as a demonstration during a painting workshop.

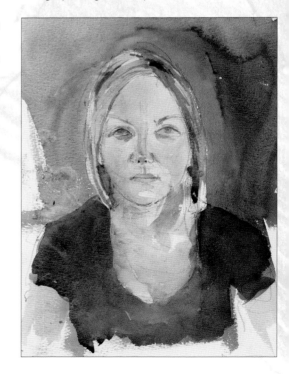

Classes and subjects

Few classes last more than two or three hours, so it is unwise to be too ambitious, unless the model will assume the same pose over a number of sessions. It can be a good idea to use the class merely to make one or more studies for a painting that can be produced later, alongside a reference photograph taken in the class

A good alternative to classes is to paint your friends or, if funds allow, a professional model. Perhaps perversely I find friends more taxing to paint from life than a class model. Watercolour requires great concentration if mistakes are to be avoided, and it is tempting for the sitter (and, less often, the artist) to initiate a conversation. A professional is more used to being still and silent.

Putting the subject at ease

If you are in the fortunate position of painting someone from life in your own home or studio – friend, model or client – it is essential to find ways of putting both of you at ease, as far as that is possible in such an artificial situation. A few minutes' worth of conversation if they are relative strangers will help. Only you will know if this has to stop when painting begins. Seating them by a window may well provide the best painting light and greatest comfort for the sitter.

You may never be as relaxed as they may become, but you should be comfortable physically. For me this means sitting at my easel, which has all my materials at hand. Others may prefer to stand, but should also have all tools within easy reach, including a chair to use during breaks, which should be frequent.

As with a portrait class, you may choose not to make a finished painting in the few hours of the sitter's presence, but make a number of studies. Photographs, informed by the live studies, can be used to make the final portrait.

Watercolour portraits from life

To create a finished portrait from life in watercolour is a tall order. Most of my experience of this is from portrait classes, where a model poses for only a short time, and a few of my efforts are shown here. On other occasions, when I have asked friends to sit for their portrait the results have been less than successful. I think this is due mostly to the practical difficulties involved. There is a need for total concentration in watercolour painting, particularly in portraiture, and this is easier in a portrait class than a one-to-one situation, where there is also a need to interact with the sitter from time to time.

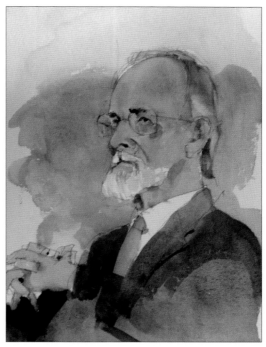

Elderly gentleman

A painting produced during a portrait class. The lighting is flat, not showing the sitter to best advantage.

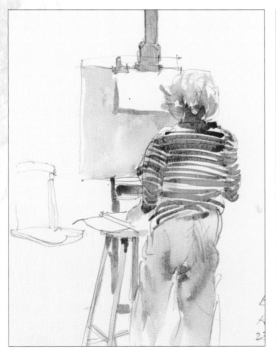

Elizabeth

Another example from a portrait class, this time a full figure study where the clothing is as important as the face. Elizabeth was one of my fellow students, sketched at the end of an intense weekend course.

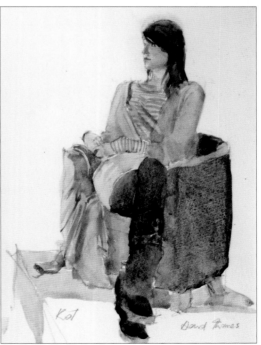

Kat

Painted from a model at another portrait class, this is in the same series as the elderly gentleman above.

Painting from photographs

Rather than advocating a photorealist approach – where the ideal result is a painting that cannot be distinguished from the photograph – I see the photograph as the first creative step in the portrait-painting process. As a result, I recommend that the artist should take their own photographs wherever possible, just as they would make their own choices of colour, composition and so forth in their portraiture.

Two approaches to gathering photographs

Because digital cameras allow many shots to be taken in rapid succession, much promising material can be gathered by photographing the subject in an informal setting. Whether drawing or painting, the artist's first task on returning home from such an assignment is rather like that of a photojournalist: to sort through the material.

The alternative approach is a more formal photography session with the subject. Here, the sitter can have more involvement in the decision about which photograph to use as the reference, and there is also more opportunity to control pose, format clothing, background, lighting and similar considerations.

Whether you use a formal or informal method of gathering your reference photographs, it is at this point that the artist stops being merely a photographer, and turns his attention to the needs of the painting. He can eliminate, change or invent a background. He can choose a landscape or portrait format and arrange his subject within it. He can combine photographic references. Once he lifts his pencil and then the brush, judgements will need to be made about colour, edges and tone, which will always serve the interests of the painting, and not be a mechanical copying of the photograph.

Using reference for painting portraits

Much of the information about drawing from photographs (see pages 44–45) applies equally to painting from them, including how to gather your own photographic reference.

Of course, painting requires some skills and knowledge quite different from drawing, and so the over following pages we examine some examples of finished watercolour portraits alongside the photographs I used as reference. As before, I explain how and why I made decisions to translate the photograph to a finished portrait. In addition, the following pages show how to combine multiple photographs into a single composition.

Using a computer

The camera will faithfully record whatever you point it at. Your control either comes at the moment of exposure by selection of clothing, lighting and pose, or later by manipulation in what used to be the darkroom, but which we now call a computer.

Although digital cameras are very good at catching informal moments which have portrait potential, they seldom occur in ideal lighting conditions or with an appropriate background. By using the contrast or brilliance controls in a computer program such as Adobe Photoshop Elements, a photograph taken in poor light can reveal hidden detail. Backgrounds become more important in a world of colour, and what is present in the photograph can be removed or modified. For example, the photographic reference for *Clara* (see page 71) was taken in a railway carriage, but the painting employs a vibrantly colourful background. This is as far as I usually go in changing the reference material; I rarely attempt to alter the colours of the original photograph using computer software, though these tools exist. Use of the computer should be seen as a tool to help your own judgement, and not a substitute for artistic rigour.

Apart from modifying the source photograph, I find the computer's capacity to enlarge details is particularly helpful when painting important parts of the portrait, such as eyes or hands. To approach a sitter close enough to see in their eyes the small changes in colour and tone – so telling in the final portrait – would be intrusive in life. A computer allows you to go as close as you need.

75

Christine

The sitter in this photograph is lit from my living room window, as with my self-portrait on pages 14–15, Unlike the self-portrait, in this instance there is no suggestion of the curtains which are behind the sitter, and the chair has been omitted. Instead, an abstract background seemed to suit.

Comparing the portraits you will see that in each the painting moves from light on the left to dark on the right. The back of her head has been allowed to merge with the background. This is a good example of how to remove extraneous detail from your photograph to allow the focus to remain on the sitter.

Edges in the context of painting refers to boundaries between objects, which can either be hard or soft. This portrait demonstrates the difference. Here, the left-hand side of the sitter's face forms a hard edge against the background. Conversely, the right-hand side merges with the background, forming a soft edge.

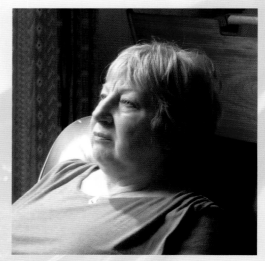

The source photograph.

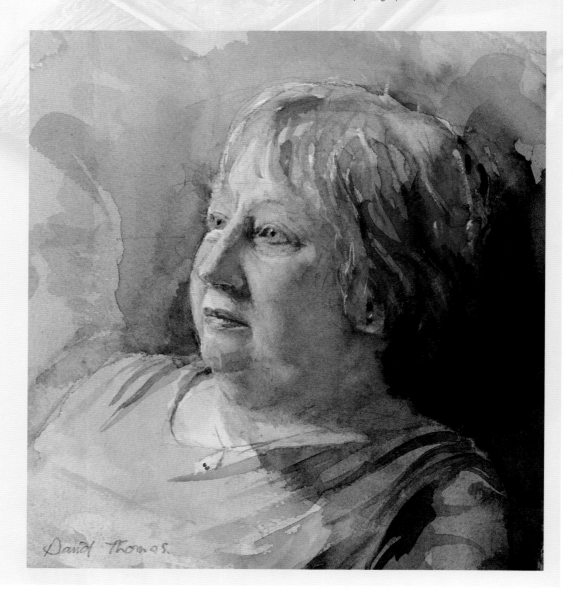

The finished painted portrait.

Making use of unpromising photographs

One should endeavour to gather the best reference you can get. However, it may be the case that it is simply impossible to get a better photograph, and you are forced to use that to which you have access. Sometimes one photograph will present a number of alternative compositions for an eventual portrait, even if it initially appears unpromising.

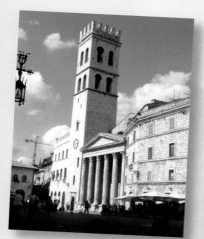

The original source photograph.

Alternative compositions

This first crop reveals a potential subject, but at this size, more architecture than figure is showing.

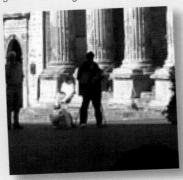

Still not right – the central placement of the figure is awkward, and does not make enough of the contrast between it and the massive columns. Note that the photograph becomes pixellated when zoomed in to this extent. However, we need only the basic composition to be clear for our purposes, so this loss in picture quality is acceptable.

Shant

This is a rather extreme example of making use of an initially unpromising photograph (see left) to create a striking portrait. The eventual subject – at the base of the columns, painting a picture of his own – is hardly discernible in the original image. This allows me the opportunity to show a few alternative possibilities for using the photograph. These are shown below, to demonstrate the other potential approaches I tried before finding the best use of the photograph.

The finished painting makes the most of the contrast between the small and shadowed figure and the large and sunlit columns, and also shows how even a small silhouette in your photograph can provide enough information to identify an individual.

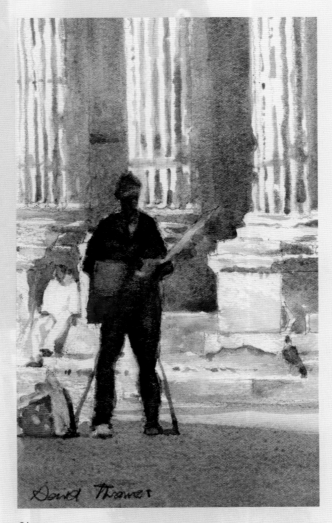

Shant

This is Shant, an aquaintance made on a painting trip in Italy, and shows him in front of the Temple of Minerva in Assisi.

Combining photographs for a single portrait

Even a seemingly perfect photograph can prove to be missing a vital piece of visual information. Furthermore, while certain aspects of the photograph might prove useful – perhaps the basic pose, for example – other details like the expression or lighting may be wrong. Taking multiple photographs and combining different parts into a single composition helps to ameliorate these potential problems.

Lavinia

For this commission, I took several photographs of the subject, Lavinia, outdoors, then returned to the living room. After rigging up a standard lamp to provide a little extra light, I took several more shots with Lavinia seated on the settee. Together we looked through all sixty photographs and made a shortlist. Consulting with the sitter like this is good, as you will discover how much latitude you have to choose between locations (inside or outside in this case) and poses. Lavinia had no preconceived ideas, apart from the position in which the finished portrait would be hung.

Once at home, I decided that the interior views would be where I would find the best material because Lavinia looked relaxed on the settee, and I felt the softer lighting suited her, though I was attracted by the dappled shadow in one of the garden shots. By combining the photograph that had the most pleasing arrangement of the hands with the one that had the most attractive smile, I arrived at the final reference.

The finished painted portrait

Meeting the client for the first time, even though there may have been telephone calls and emails beforehand, is a key moment in the commissioning process. In this case it was a particular pleasure since it involved a young and beautiful lady, Lavinia. I was met by her at the railway station and driven the short distance to her and her husband's ground floor flat in Belsize Park.

I found painting this portrait to be a challenging and rewarding task. I felt I had done justice to my attractive client, and she must have thought so too, as the portrait now hangs in the room where its life began.

A selection of the photographs taken for reference.

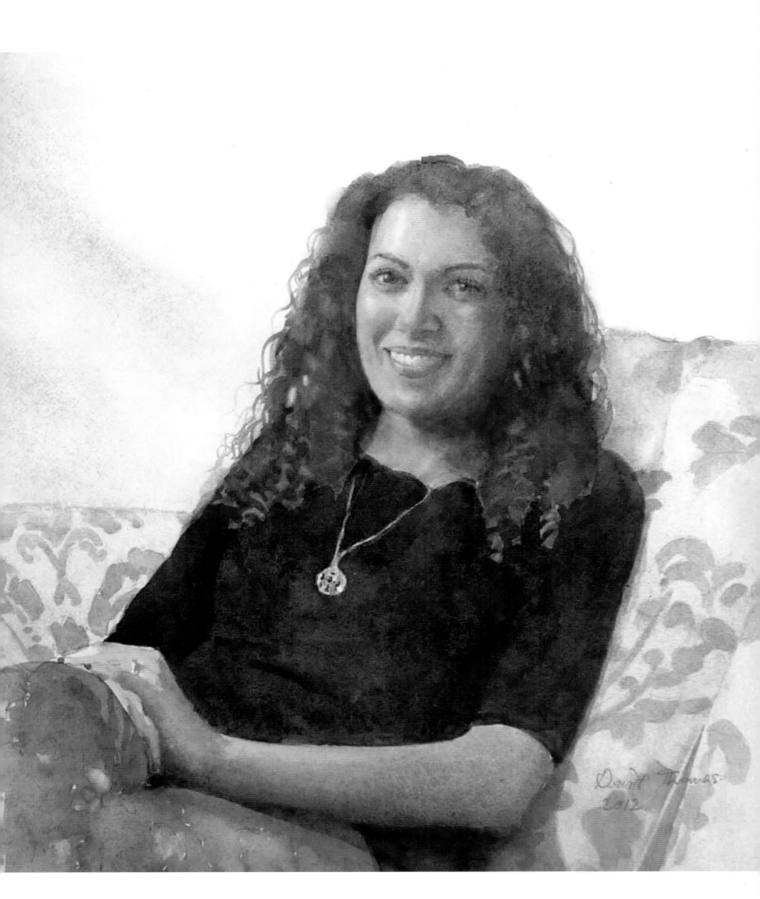

Photographs for a group portrait

As mentioned on pages 28–29, group portraits present logistical and technical challenges. This is particularly the case with large groups, but even small groups not used to sitting still for a photograph, such as children, can be difficult. In these cases, accepting that this cannot be a live project but will be done from photographs is a good idea. It is still necessary to get everyone together and at least facing in the right direction, but the digital camera's capacity for taking shots in quick succession can be exploited, particularly for outside shots.

Taking multiple photographs is a good idea because it reduces the chance that you lose vital information – such as an individual's eye colour because they blinked at an inopportune moment – and means that you have multiple options to show all your sitters in the best possible way.

Group portraits may not benefit from a single focal point. Instead, you can aim to show all faces to equal effect with multiple focal points, as in the example on these pages.

The Monaghans

Getting good reference means being willing to rethink your initial ideas. My intended approach for this commissioned group portrait was to have the children outside. Despite producing some pleasant photographs, as shown to the right, none seemed to suggest a natural group.

Rethinking the photography shoot, we moved indoors and tried another approach. The photographs shown below were combined into the final painting on the facing page. Note how I have combined the most suitable facial expression for each child into the finished piece.

The indoor shots, taken with a mixture of natural and artificial light sources, provided most of the colour information, but the earlier outdoor shots still proved useful, as they provided some excellent natural lighting to help guide the colour choices.

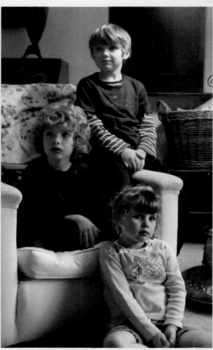
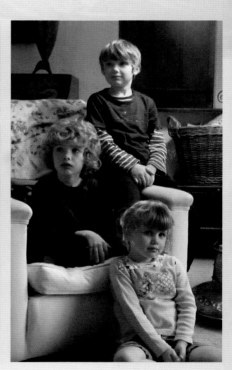

Opposite:
The finished painted portrait.

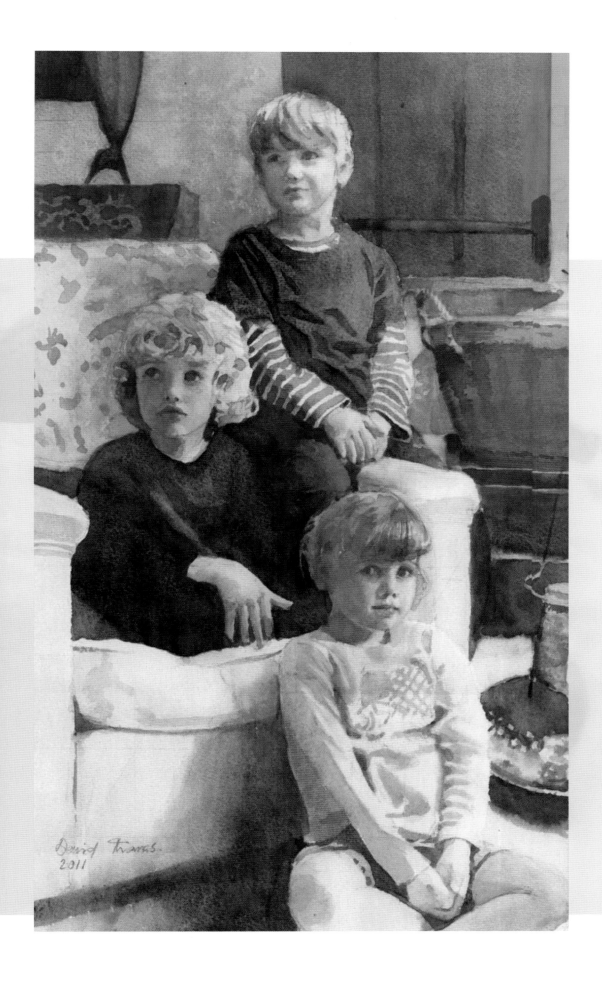

David Travis.
2011

Perfecting your portraits

This chapter examines the hair, eyes and hands to draw your attention to these important specific details and show you how careful observation can help to achieve realistic portraits.

Hair is technically challenging. Ideally, only close inspection will reveal the painter's artistry in suggesting the form of the hair without the necessity of painting every fibre.

Of the three subjects in this chapter, the eyes are perhaps the most important – as in life, so in portraits. When we meet someone for the first time we look into their eyes, perhaps because we feel we will see their thoughts expressed there. To paint them well requires fine brush control, dealing with changes of tone and colour in a very small area.

Hands can easily look like a bunch of bananas. They sometimes are prominent in portraiture, usually when supporting the face. When they play a minor role they should be simplified so as not to draw attention away from the main subject.

The information and suggestions on the following pages will help you to give your very best when approaching these challenging but rewarding parts of a painting, and enable you to get the most out of your own portraits.

Opposite:
Geoff

This study came from a meeting in a pub. A quick snapshot I took led to this portrait. The ambient light of the pub's original gas lighting was supplemented with a little natural light from a small window to the left which resulted in a warm glow to Geoff's naturally ruddy complexion. The direct light produces interesting modelling without being harsh.

The subtlety of watercolour can be exploited in areas like the highlight on the forehead. Should you mask out the area around it, you would find it is quite dark in tone. To think all highlights need to approach the white of untouched paper is a mistake.

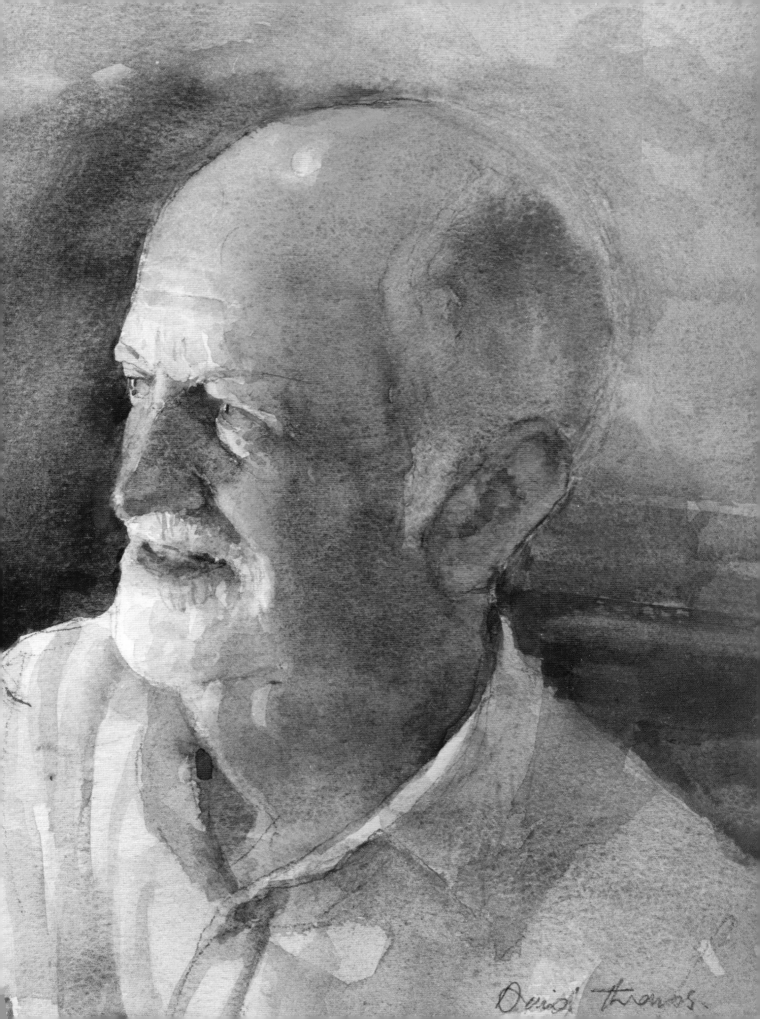

David Thomas.

Hair

Good artists are able to simplify complex elements, conveying them with a few deft strokes of the brush. Nothing in a portrait demands this painterly approach more than hair. Colour, shape and texture lend themselves to suggestion rather than a photographic replication.

Hair, whatever the colour, is not uniformly red, blond or brown; nor is it evenly lit. If the tone and colour are captured with accuracy, surprisingly little further information is required. There are exceptions, and Arthur's hair (see below right) was one, but even here there is simplification possible within its apparent complexity.

Look for colour variation and tonal variation. Often the deepest tone is at the nape of the neck.

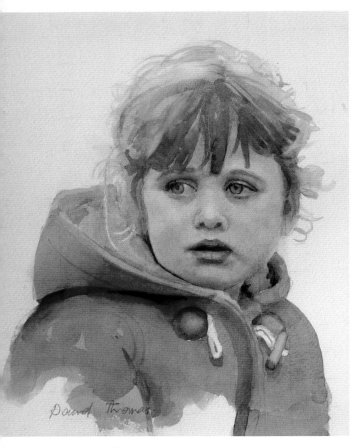

Lydia

The hair has been suggested rather than painted photographically. Simplifying complexity is one of the things that makes a good painting.

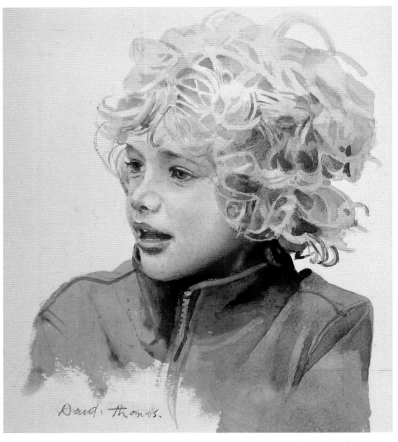

Arthur

This delightfully unruly hair was a challenge to paint. I could not find a shortcut to suggest its complexity, so resorted to careful initial pencil drawing.

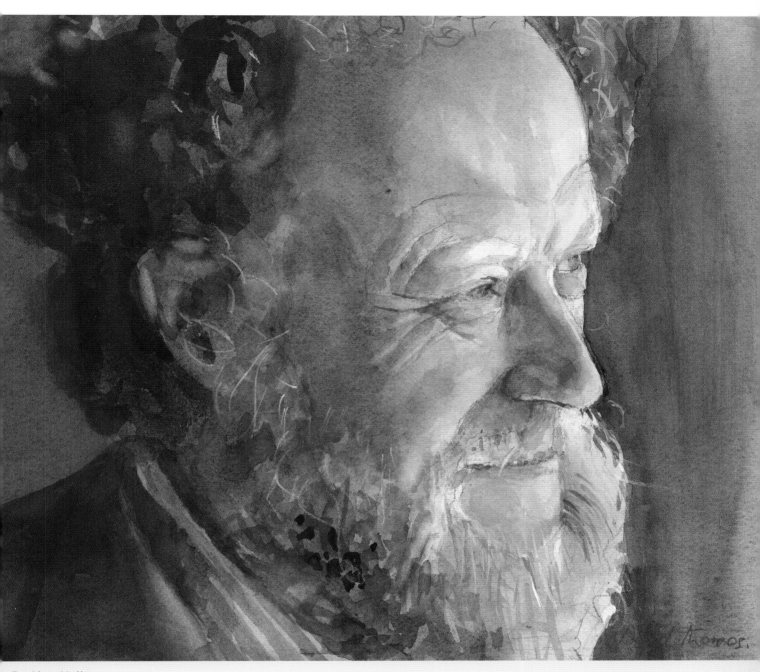

Dr Alan Kelly

A beard can add excitement for a portrait painter, particularly if it belongs to a face that already has character. This portrait is a good demonstration of the general rule that a wide variation in both tone and colour can be found in a single head of hair. The actual colours are grey with a touch of ginger for the beard, and a light brown for the head hair. What we see in the painting is hardly any light brown (it is restricted to the hair at the top right of the head) and a tonal range from white under the nose to almost black at the back of the head. These effects are caused by the light from the window striking one side of the face, and leaving the other side in shade.

On the right-hand side of the beard, a few individual hairs have been painted, while a white charcoal pencil was used to pick out some white hairs in the shaded side. This approach produces a more appropriate pale tone than the bright whites made by the techniques described on page 67. These individual hairs, set against the mass of colour beneath, is enough to convince the casual eye that they are seeing a bushy, carefully painted, hairy beard.

Eyes and hands

Some of the most expressive parts of the body, eyes and hands are both worthy of closer study in order to achieve a close resemblance to your sitter.

Eyes

Often the focal point of your portrait, eyes merit particular attention. Paradoxically, it is a mistake to paint them in such a way as to separate them from the rest of the face. They are each set in an eye socket, and this is as important to paint correctly as the eye itself .

Sometimes eyes will be shaded (as in the portrait below left) and sometimes they will be more clearly lit. In the former case, paint only what you see. If there is no highlight in the eye, do not paint one. In the latter case, try to preserve the white of the paper for the highlight. It is always brighter than using an opaque white paint.

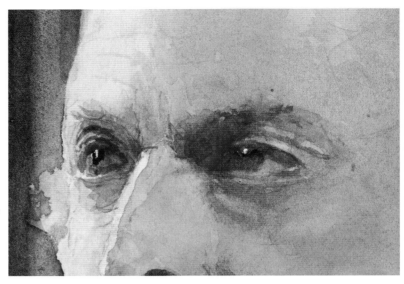

Detail of eyes from *Self-portrait*

Painting these eyes required careful initial drawing and then equal care to paint the many colour and tonal shifts in these small areas. Eyes as clearly lit as these will always demand all the observational and practical skill at the artist's command. The full image can be seen on pages 14–15.

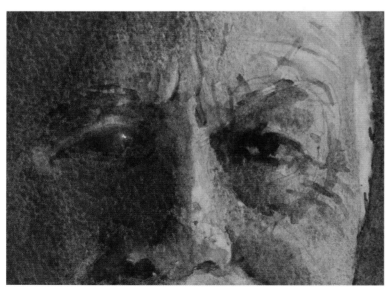

Detail of eyes from *George*

As with the eyes from my self-portrait (above), accurate drawing was required for this sitter's eyes. Because there is not so much colour and tonal shift in these shadowed eyes, what little there is becomes all the more important to get right. In the eye to the right, the white of the eye appears a dark blue-grey in this light. Note that there is a visible highlight only in the eye to the left. The eye sockets are well-defined, as they often are in older faces. The full image can be seen on page 101.

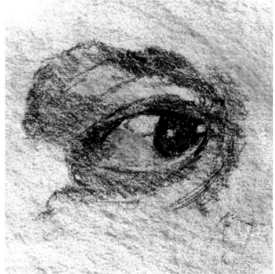

Eye in charcoal

When working in monochrome, look hard for the tones within the iris. The pupil may be the darkest element, and may have the highlight – the brightest part – set against it.

Hands

Rarely are hands painted as a subject in their own right. Nevertheless they are worthy of separate study for the aspiring portrait artist, one famous example being *Praying Hands*, by the Renaissance-era German painter Albrecht Dürer.

Even when simplified in order not to distract from the main subject, hands should be painted with accuracy and care because they make a telling contribution to a composition.

As mentioned earlier, drawing accuracy in portraiture is essential. This applies to hands as much as to faces. Unless care is taken, the fingers can come to resemble bananas or sausages. With that caveat, hands do not always need the attention given to them in the detail at the top right, or the life drawing study below, but can be simplified as with the clasped hands from the Katie portrait, and in many other examples throughout the book.

If you have taken care and succeeded in capturing your subject's facial features, you should not risk letting the painting down by becoming careless with the hands. Just as with the face, it is easy to spot a drawing error.

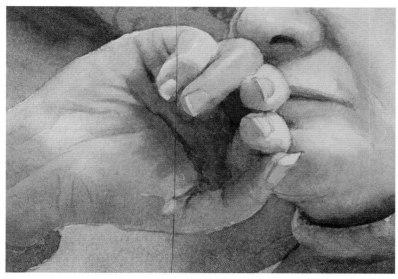

Underside of hand

Hands generally have only a small variation in colour and can be treated as tonal studies within a portrait. However, any hand that appears close to or touching the face needs painting with more care and detail. Other examples of the hand touching the face can be seen in Elderly Gentleman *on page 25 and* Bob *on page 125.*

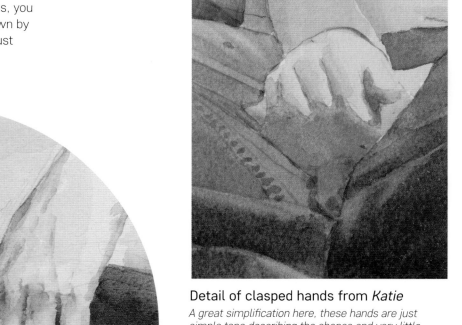

Detail of clasped hands from *Katie*

A great simplification here, these hands are just simple tone describing the shapes and very little colour variation. This ensures they do not draw attention from the focal point of the portrait – the face. The full image can be seen on page 23.

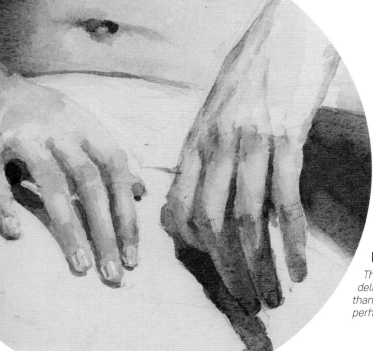

Relaxed hands

This study was made during a life drawing class. It is thus a deliberate effort to make an accurate study of hands rather than a detail from a larger portrait – though this example is perhaps not to be compared with Dürer's work.

Age

Young skin is made for portraying in watercolour. The medium's outstanding characteristic is the ability to make gentle gradations of tone and colour, controlled by the very water from which it takes its name. These are just what we see in young faces.

It is easy to think that a very light tone is required for young faces, which tend to have paler skin than adults. However, the strength of tone required is often underestimated. The other reason you will often make your initial skin wash too pale is the result of another unique aspect of the medium: its habit of drying lighter.

A mix of raw sienna and cadmium red makes a good basis for European youthful skin – with the addition of French ultramarine for African skintones. Drop in strong brushfuls of these colours wet-into-wet where you see the relevant colour is needed. Practise with the watercolour technique exercises on pages 62–67 will help you judge how much pigment and water to use so that the watercolour is allowed to behave naturally, and produce those infinitely subtle changes in tone and colour. It is fine to move the brush about to get the colour where you want it to be, as long as you stop before it begins to dry. There is always a balance to be found between you controlling the watercolour, and it controlling you.

Faces become more interesting as they age, and life's triumphs and troubles become etched there for all to see. As a result, elderly people's faces do not exploit these aspects of watercolour to the same degree. Old skin has blemishes and signs of life's wear and tear, and are often fascinating to paint. In addition, the viewer's expectation of wrinkles and imperfections in older faces makes them a lot easier to paint than the unblemished young, where even a tiny mark can stand out.

 Tip

Some photo editing software includes tools that allow you to sample colours, which will help you judge the hue you need. You may be surprised by the depth of tone required for skin.

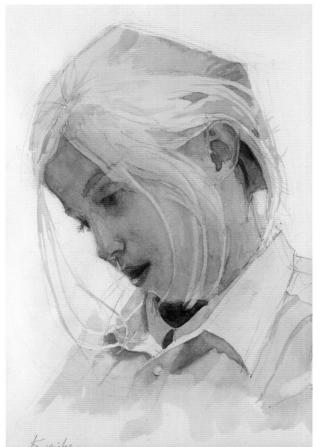

Top:
Miles

Miles has a relatively pale face, yet the general skin tone I had to apply was quite strong in order to accommodate the medium's quality of becoming lighter in tone as it dries. The source photograph was supplied by the client and so this portrait is one of the few instances in this book where I have used a photograph taken by someone else.

Left:
Emily

The tone used for the skintone here is even darker than in Miles, though here this is because her face is in shadow. Both portrait sketches needed the pigment to blend with the water (the wet-into-wet technique) yet be controlled. Compositionally, this was based on a photograph chosen from a number of informal shots, which worked because it caught a natural unposed moment rather than because of unusual lighting or composition.

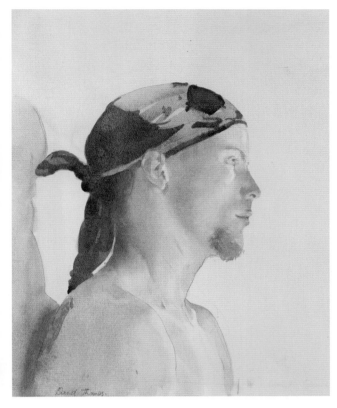

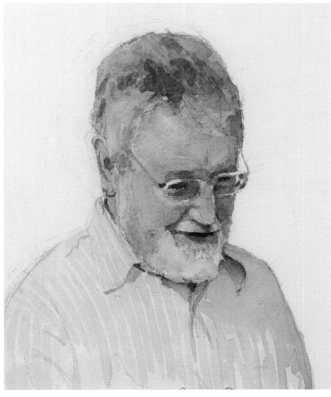

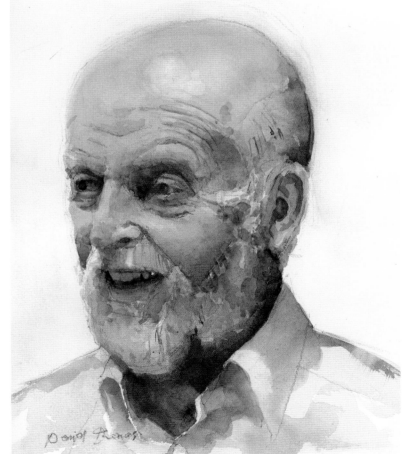

Top left:

Dave

A youth rather than a baby, but still with the pale, clear skin of a child, Dave was sitting for a portrait class. The source photograph for this portrait can be seen on page 44.

In this profile pose, the light coming from the right has not produced much modelling, and so painting the skin was an exercise in gentle tone and colour change within a narrow range, and from a base tone that was genuinely pale.

Above:

Clive

Produced from a long-distance photograph taken outside, at the subject's seventieth birthday party, there was just enough information to make this portrait, which once again shows the value of the digital camera.

As was the case with Miles and Emily, on the opposite page, the merit is the unposed moment, not lighting or a particular composition. His greying hair and beard are clues that the subject has left youth behind (although I know he is still young at heart). Compare the skin texture with that of Ken (left).

Left:

Ken

Compare this with Geoff on page 83. The lighting in both cases is quite soft, but effective. Here, the texture of the skin is more obvious; and some hard lines have been created with fine marks.

THE PORTRAITS

The following pages take you step by step through the creation of three demonstration portraits. They represent the culmination of the rest of the book.

The stages are so closely spaced that it is possible to create a facsimile of each demonstration if you diligently replicate the process described. Doing so will teach you much about the behaviour of watercolour, and for that reason alone may be worth embarking upon. My hope for any reader is that you will quickly pass beyond the need to copy my work, or anyone else's for that matter, and reach the point of having the confidence to strike out on your own with your portrait painting.

The ingredients for success are much the same as for any other creative endeavour: enthusiasm, persistence, ability. Note the order. The first two qualities are essential. I prize drawing ability highly as a means to the watercolour portrait painter's ends, and if this is in your possession you are already half way there, but even if blessed with only a little of this facility, practice will improve your performance. Drawing and painting are both ways of seeing, and can be cultivated.

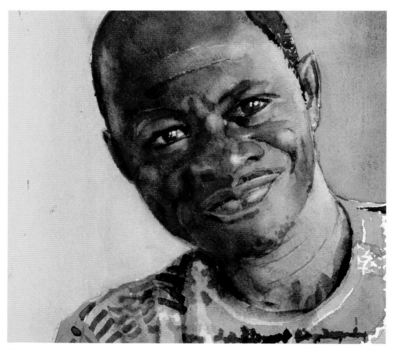

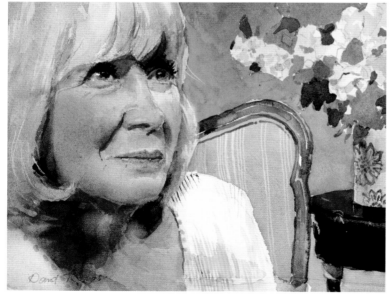

The book has been arranged in a logical order, and will yield the best results if the reader follows the same progression: sketching, drawing, painting. Sketching is fun, drawing is absorbing, and painting is endlessly fascinating. It is, perhaps thankfully, beyond mastery, and so will provide a lifetime of enjoyable development in your skills. Start with the fun and you will find your sketches become drawings and your fledgling painting efforts will progress quickly because they have a sound foundation.

90

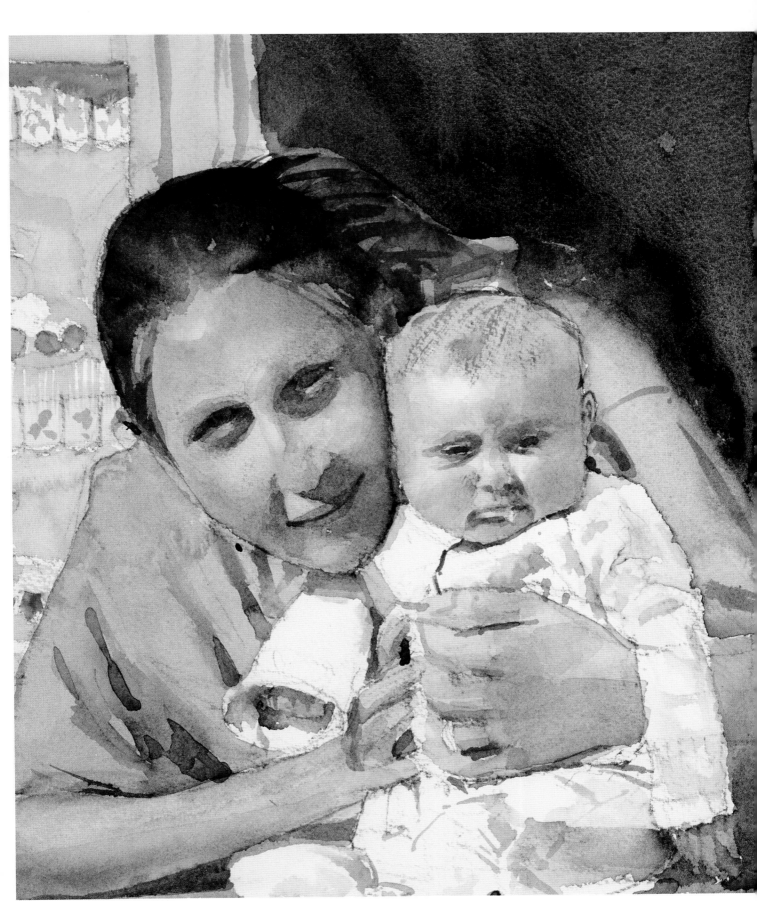

Alexander

Full face portrait

A nominally 'black' face, just like a nominally 'white' one, has a surprising number of colours in it. Skintones pose the same challenges of subtle tonal and colour variation, however they might be labelled.

The dark skintone of this subject also invites the use of bright colour as a contrast. Here this is seen in Alexander's own choice of a coloured shirt, and my choice of background. A similar idea – of a bright, contrasting background to set off the subject's dark-toned skin – was explored in the background of *Clara* (see page 71).

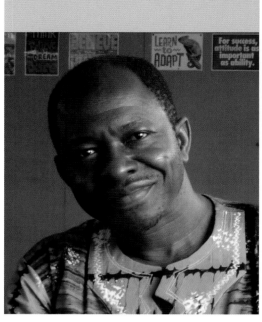

The source photograph used for this painting.

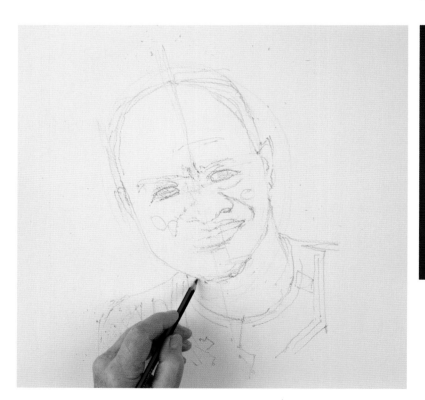

You will need

38 x 38cm (15 x 15in) 638gsm (300lb) Not watercolour paper

6B pencil

Masking tape

Plastic eraser

Brushes: size 8 round sable, size 0 round, 10mm (⅜in) flat, size 4 round, 5mm (¼in) flat hog bristle

Colours: cadmium red, French ultramarine, burnt sienna, cerulean blue, cadmium yellow, perylene green, new gamboge yellow, quinacridone violet

Kitchen paper

Basic lines

Use masking tape to secure your paper to the board. Use a 6B pencil to draw in the basic shapes of the head, starting with an oval and the blocking in the features. For a simple forward-facing composition like this, it would be unusual to have the portrait off centre, so keep the head central.

It is important to get the angle of the head correct, so you might find a vertical line that runs down the centre of the face helps you. Add the neck and shoulders, as well as the line of the collar. You might also add some small circles on the cheeks and nose to help remind you to reserve highlights. Above all, make sure you are filling the space effectively.

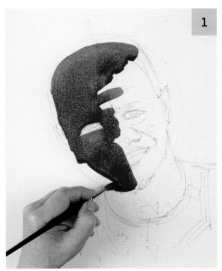

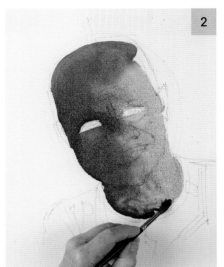

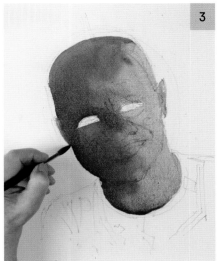

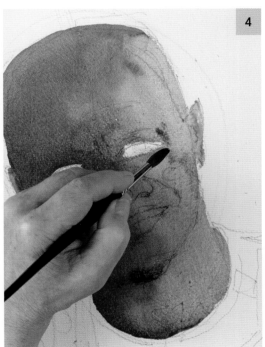

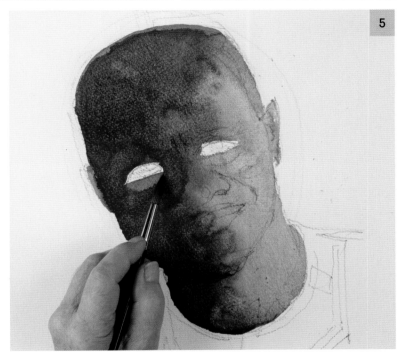

The face

1 Prepare a large amount of cadmium red, French ultramarine and burnt sienna as the base skin mix. Starting from the top of the head, begin to lay in a flat wash with the size 8 round brush. Work down the left-hand side of the face, avoiding the eyes.

2 Without washing the brush, pick up cerulean blue and lay it in on the right-hand side of the face, allowing it to bleed into the base skin mix. Extend these colours down to the collar.

3 Still using the size 8 round brush, add in the ears using the base skin mix.

4 While the paint remains wet, use the tip of the size 8 to add in some shadows on the right-hand side of the face, such as the large crease on the man's brow, on the chin, and around the side of the face by the eye.

5 Lay in more of the base skin mix on the forehead and hair line, then reinforce the shadows on the left-hand side in the same way. Add some touches of French ultramarine wet-in-wet. Leave the area under the eye reserved. Allow the painting to dry completely before continuing.

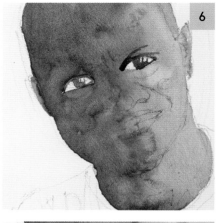

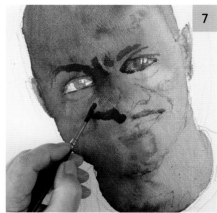

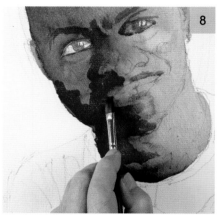

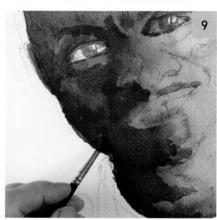

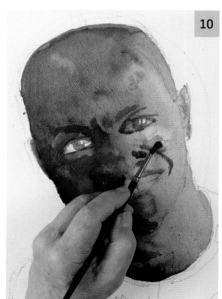

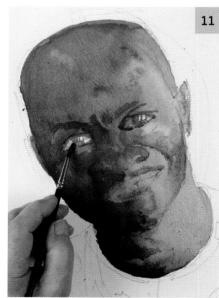

6 Using the base skin mix (cadmium red, French ultramarine and burnt sienna) and the size 0 round, establish the upper eyelid on the left-hand eye. Add the corner of the eye and then the iris with the same colour. Work carefully to leave a large space for the highlight. Paint the other eye in the same way, adding the shadow of the eyelid, and a hint of cadmium red in the corners.

7 Change to the size 4 round brush and paint in the shadow around the left eye and the side of the nose using the base skin mix. Blend the colour away down the side of the nose using clean water. Add a touch of cadmium red to the mix and add the man's moustache, softening the colour upwards into the lip. Using this as a guide, return to the base skin mix and add the shadow of the nose.

8 Continue to develop the shadow on the left of his face, filling in the lower left and establishing his cheek. Work down over the chin and neck, bringing the shape of his neck out. Work round his mouth and blend the colour under his lower lip.

9 Add hints of cadmium red on the cheek highlight area you marked earlier, and a hint of cerulean blue on the side of his cheek. While the colours are wet, draw the base skin mix up and around these areas, allowing the colours to bleed into one another. These add warm highlights and cool reflected light which help to give shape to the shadow areas.

10 Begin to work over on the right-hand side of the face, using the base skin mix to add modelling, and small areas of cadmium red for warmth.

11 Since this side of the face in facing the light, use the base skin mix slightly diluted and soften the colour in around the ear and chin. Add a hint of cerulean blue to the left-hand eye, to stop the white being too stark.

12 Still using the size 4 round brush, add more cool reflected light at the top left using cerulean blue, then add some modelling near the collar to show the muscles of his neck, using the base skin mix. Allow the painting to dry, then dilute the base skin mix and wash it over the neck.

13 Use a damp 10mm (⅜in) flat brush to lift out some colour on the right-hand side of the neck, then use the size 8 brush to lay in some dilute cerulean blue.

14 Make a dark mix of French ultramarine and burnt sienna. Use the end of the size 8 round brush to apply the paint with a dabbing motion around his temples, so some of the skin shows through round the short hair. Extend the hair up over his head, following the hairline on the right-hand side, then lay in a large amount of the base skin mix on the forehead. Working wet-in-wet, draw this colour down to develop the modelling on his forehead and around his brows.

15 Still using the size 8 round brush, use a diluted version of the base skin mix to develop the modelling on the face, adding depth to the right-hand cheek, shaping the nostrils and left-hand side of the face, before working down the jawline.

16 Change to the size 0 round brush and use the undiluted base skin mix (cadmium red, French ultramarine and burnt sienna) to deepen the tone in the shadow of his cheek on the right-hand side, and also to strengthen the tone in and around the eyes. When adding the layer here, avoid the right-hand sides of the irises. This helps to build up the depth and suggest the curvature of the eye.

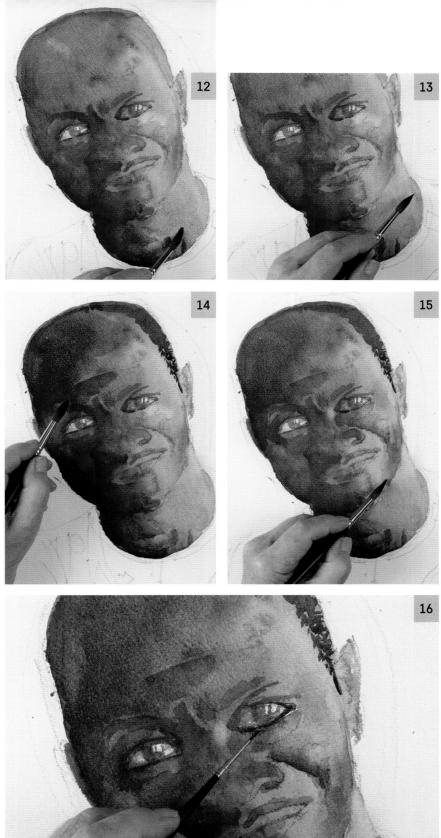

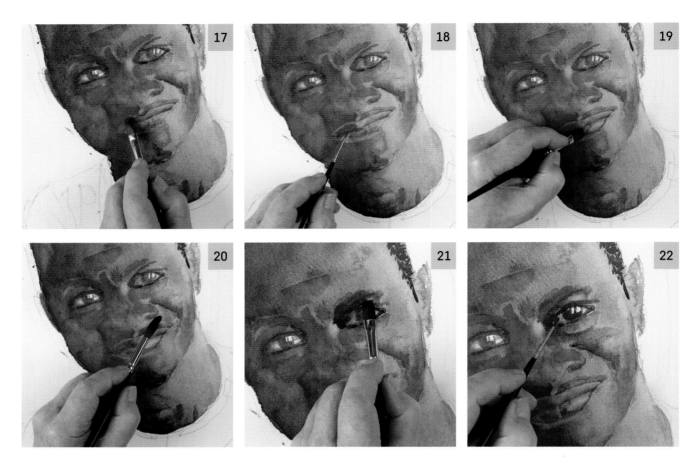

17 Draw the line of the mouth using the size 0 round and the base skin mix. Add a hint of cadmium red to the lips on the shadow side of the face, then dilute a little of the base skin mix (cadmium red, French ultramarine and burnt sienna) and apply it to the lower right of the lips. Next, use the damp 10mm (⅜in) flat brush to lift out a highlight on the top lip.

18 Allow to dry, then add a hint more cadmium red to the base skin mix and add some warmth and colour to the lips, working up to, but not over, the highlight.

19 Add some definition on the right-hand side of the lower lip with a touch of the dark mix (French ultramarine and burnt sienna) near the corner and add tonal contrast by lifting out a highlight on the lip here with the 10mm (⅜in) flat.

20 Use the size 8 round to add in a glaze of dilute cerulean blue around his mouth, suggesting the beard and moustache area.

21 Using the size 4 round, apply an overlaying glaze of the base skin mix to soften the lines around the eye. Add a little more burnt sienna wet-in-wet, and lift out a highlight below the eyebrow using the 10mm (⅜in) flat.

22 Extend the warmer burnt sienna-tinged base skin mix across the cheek with the size 4 round. Use the dark mix to line the top of the eye and strengthen the iris and pupil, then add a hint of the base skin mix to cadmium red and touch in the corner of the eye.

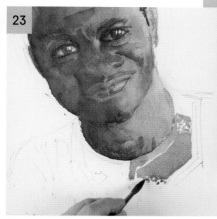

Clothing and detail

At this point, the head still needs to be put in context. As a result, even the hint of clothing that we see on this head-and-shoulders portrait is important in suggesting the sitter's character, so it must be portrayed accurately.

When painting complex patterns, as on this man's shirt, strike a balance between the time taken and painstaking accuracy. The suggestion of a complex pattern in clothing is often just as effective in a finished portrait – sometimes more so, as over-complicated patterns can draw the eye and detract from the focus.

23 Prepare a green mix from cadmium yellow, perylene green and a little cerulean blue. Use the tip of the size 8 round brush to add the pattern and broad strokes for the plainer areas, begin to paint in his t-shirt. Leave a gap of clean white paper between the fabric of the shirt and the collar, to add some definition to what might otherwise be quite a shapeless form.

24 Continue to paint in the shirt, introducing a yellow-green mix of perylene green and raw sienna to prevent the top becoming monotone. Use a strong version of the dark mix (French ultramarine and burnt sienna) to add in the darker parts of the pattern. Dilute the mix for the some overlaying shadow and creases, particularly on the left-hand side.

25 Still using the size 8 round brush, add in the horizontal stripe across the chest with the same strong dark mix. Use the point of the brush to develop the detail.

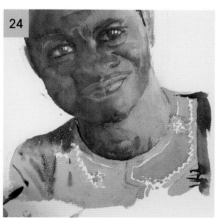

26 Use the 5mm (¼in) hog brush to wet the highlight area on the tip of the nose and lift it out with a piece of kitchen paper. Once dry, change to the size 4 brush with the base skin mix (cadmium red, French ultramarine and burnt sienna) to strengthen the darks of the nose, particularly on the shadow side and the nostrils.

27 Use the size 4 brush to narrow the eye slightly with the base skin mix, then add a hint of cobalt blue to the white of the left-hand eye for shading.

28 Add a little French ultramarine to burnt sienna and use the size 0 round to develop the shape of the ear. Drop in a little of the dark mix (French ultramarine and burnt sienna) to vary the tone. Allow the painting to dry before continuing.

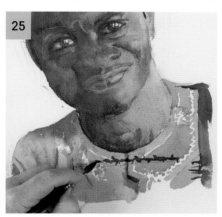

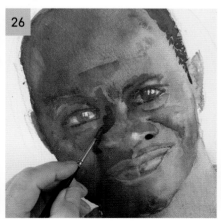

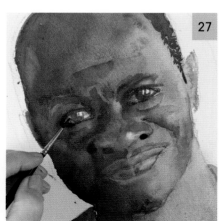

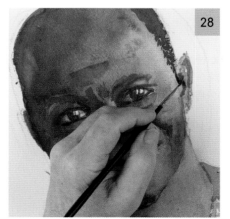

Background

The background of this portrait is an opportunity to practise your wash skills. Because this part of the painting is worked wet-in-wet, it is important to prepare properly before you begin. I suggest that you re-familiarise yourself with the flat wash techniques on pages 62–63 before you begin.

This background is a variegated, or gradated, wash. This means it includes multiple different colours, unlike the flat washes described earlier. Nevertheless, the basic principles of the technique are fundamentally identical.

This background is simple but effective in introducing some bright colours that enliven the portrait and help get the man's character across. In addition, it helps create impact through an effect called counterchange. The lighter part of the background sits behind the darker, shaded side of the portrait, while the darker colours contrast with the highlighted part of the man's face.

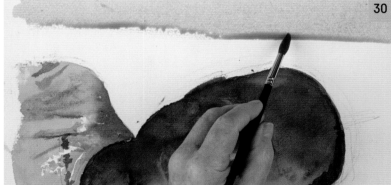

29 Use the dark mix to add the shadow of the collar then turn the picture ninety degrees clockwise, so the shaded part of the face is further away from you. Prepare wells of the following colours: new gamboge yellow, quinacridone violet and cadmium red.

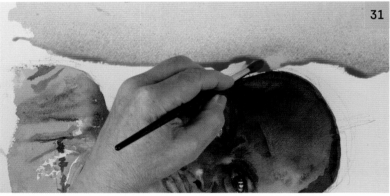

30 Starting from the top, use the size 8 round brush to begin to lay in a flat wash of new gamboge yellow.

31 Continue to work down the painting with long horizontal strokes, and introduce cadmium red wet-in-wet.

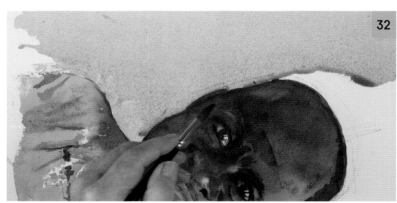

32 Work the colour down and around the figure, working right up to, but not over, the face. When the head gets in the way of the horizontal strokes, work each section in turn. Work quickly, so that the paint elsewhere does not dry.

33 Continue working round the head and towards you, introducing the quinacridone violet wash.

34 Work right to the edge of the painting. While the wash remains wet, introduce some touches of French ultramarine into the part closer to you.

35 Add a few further touches of French ultramarine, then leave the painting to dry naturally.

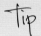

French ultramarine has a granulating quality, whereby the particles of pigment will settle into the texture of the paper. Using a hair dryer to speed up the drying will retard or stop this effect, so do allow the painting to dry naturally to achieve a wonderful textured result.

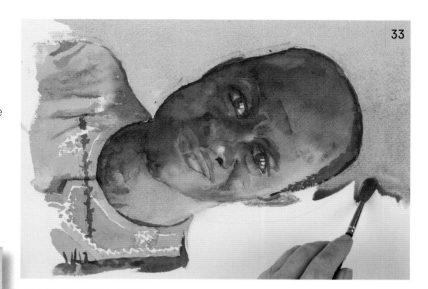

33

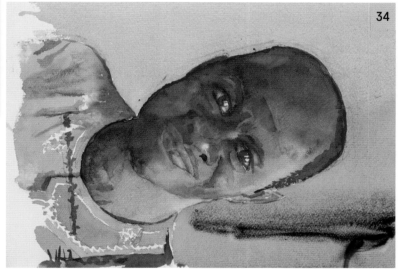

34

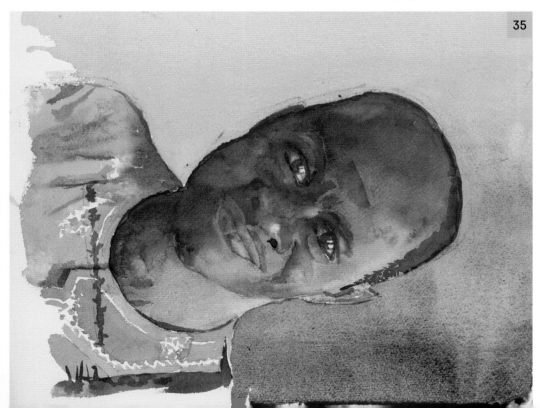

35

Overleaf:
The finished painting.

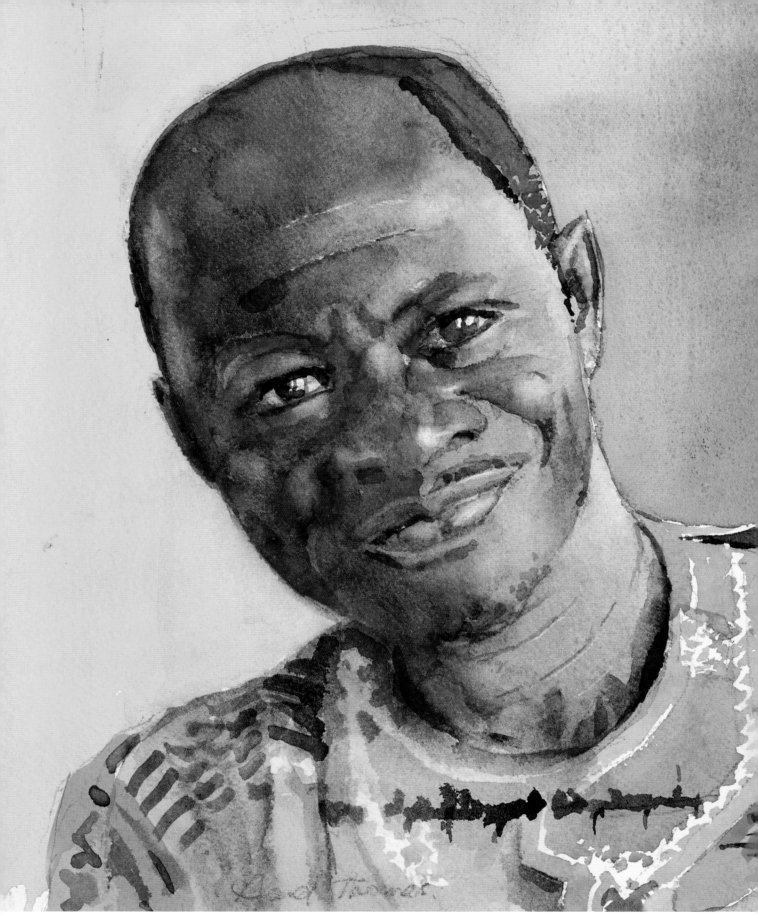

The finished painted portrait.

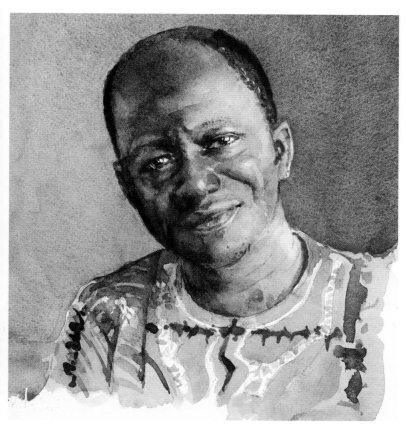

Alexander #2

This version of the portrait, made from a photograph taken at the same times as the one used in the project, has a slightly softer expression. As a result, I have used a more muted background to complement, rather than contrast with, the sitter.

It also features a vignette finish, which means that there is no hard edge to the image at the left-hand side and bottom. Instead, it simply fades away to white paper. This is a good way to ensure that the focus of the painting remains on the face itself.

George

This is a white-skinned older man, but the overall painting shows a similar strength of tone, lighting and a slightly graded background.

It is often effective to have the darker side of the face set against the lighter side of the background, so that there is a tonal contrast on both sides of the face, making it stand out.

Equally, it can be good to blend one side against the background, so the edge of the face is ill-defined or completely lost. This applies both to monochrome drawn work (as in Zoe, page 45) and to colour portraits, as demonstrated here and in Christine, on page 76.

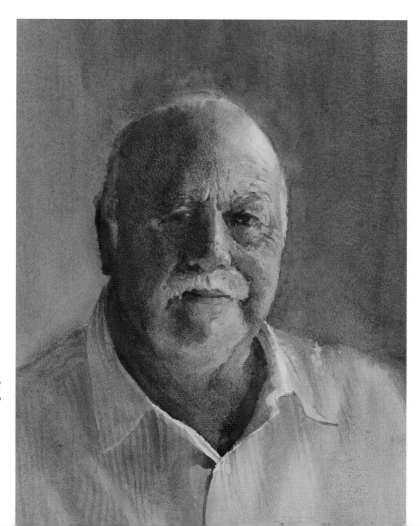

Mother and baby

Double portrait

The image of a mother and child is particularly connected with the birth of Christianity, but it is embedded in every culture, and so constantly appears in the paintings of all nations.

This portrait is from a photograph I took while in the Dordogne region of south-west France, and was an unposed and fortuitous moment. Like many portraits, it is a test of the artist's ability to capture the texture and colour of skin and clothing.

You will need

38 x 38cm (15 x 15in) 638gsm (300lb) Not watercolour paper 6B pencil

Masking tape

Plastic eraser

Water pot

Kitchen paper

Brushes: size 8 round sable, size 4 round sable, size 0 round, 10mm (³⁄₈in) flat

Colours: raw sienna, quinacridone violet, French ultramarine, burnt sienna, cadmium red, cerulean blue, cadmium yellow, perylene green, viridian, burnt umber

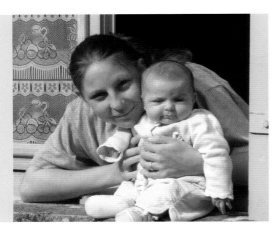

The source photograph used for this painting.

Basic lines

Use masking tape to secure your paper to the board, then use light strokes of the 6B pencil to establish the basic positions of the heads and the ledge. Make sure to make the most of the available space. Develop the shape and features of the mother and baby.

Once you are happy that you have achieved a likeness, block in the main shapes of the baby's body, and the mother's hand around him. Building outwards, add the mother's body and surrounding window. With the main sketch in place, pause and evaluate the drawing before adding some finer details like the mother's hair and baby's hands. Here, I have used an eraser to soften the lines on the mother's face and redrawn them. Do not add any tone to the drawing.

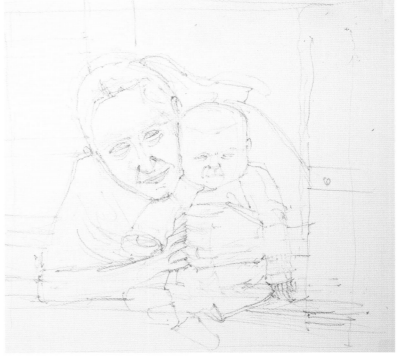

Tip

As you develop the detail, it may become apparent that the proportions are slightly wrong. The important thing is not to panic. Since everything is lightly drawn with pencil, things can easily be adjusted.

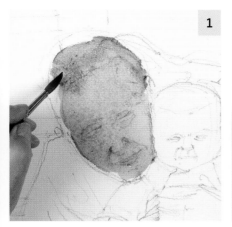

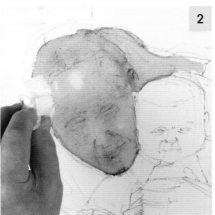

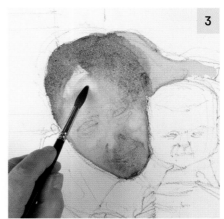

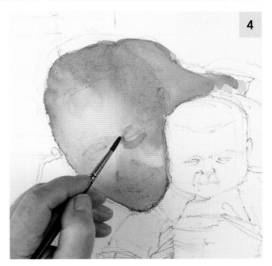

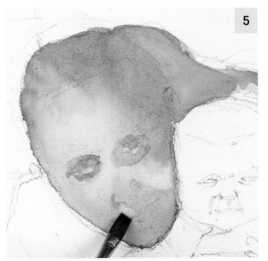

The faces

These early stages concentrate on using the wash and wet-into-wet techniques to develop what will become the focal point of the painting – the faces of the two figures.

We begin with the mother's head, painting in the face and hair, then turn to the baby. These stages use some colours you might expect, while others, such as green, may seem counterintuitive when painting portraits. The human face contains all sorts of subtle hues. Pay close attention to your source material and trust your eyes.

1 Make a skin mix of raw sienna, quinacridone violet and a touch of French ultramarine and apply it to the mother's face using a size 8 round sable. While the colour is wet, mix burnt sienna with French ultramarine and paint in the hair on her head.

2 Using the same brush, add raw sienna for the ponytail. While the paint remains wet, lift out some highlights on the nose, cheeks and forehead using clean kitchen paper as described on page 66.

3 Add shading below the nose using a small amount of a mix of French ultramarine and cadmium red. Quickly rinse the brush, remove excess water, and use it to move the colours around a little to develop some modelling on the face. Avoid the impulse to fiddle, and let the colour blend naturally. The brush can also be used to lift out some colour if necessary.

4 Shade the ponytail using a mix of raw sienna and burnt sienna, then let the head and hair dry completely before continuing. Change to a size 4 round and use a dilute mix of quinacridone violet and burnt sienna to begin to establish the shading round the eye.

5 Change to a size 0 round and use a dilute mix of viridian and French ultramarine to paint in the iris, then paint the other eye in the same way. With the eyes established, you can begin to identify the structure of the face a little better. If there are any areas that need to be lightened, lift them out using a damp 10mm (⅜in) flat brush, gently wetting and drawing the colour away to leave a highlight.

6 Using the same two mixes (quinacridone violet and burnt sienna, and viridian and French ultramarine), develop the eyes gradually, building up the area around the eye sockets and working away from the eyes themselves. Apply the paint with the size 0 round and draw it about with the 10mm (⅜in) flat brush. Use a subtle glaze of viridian while the paint remains somewhat wet to establish the eyebrows.

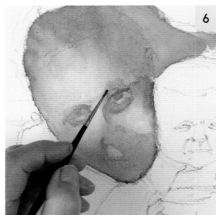

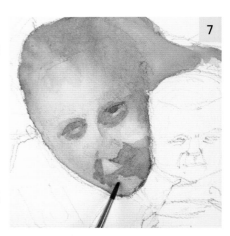

7 Continue developing the eyes using dilute overlaying glazes of the same mixes. Change freely between the size 4, size 0 and 10mm (⅜in) flat brush to apply and move the colours. Using a slightly stronger version of the same mixes, develop the shading below the nose and cheeks.

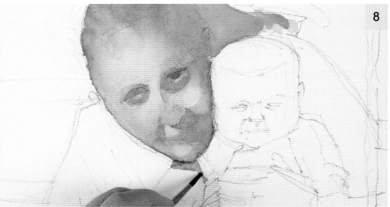

8 Work particularly carefully around the mouth. The same mixes and brushes are used to apply the paint on the chin, but you can also lift out colour here to help adjust shapes. As you come to the edges of the face, begin to paint in the surrounding areas. This allows you to use the mixes you already have for the skin where they are reflected. Here, the shadow on the baby's sleeve is painted with French ultramarine, and then a little of the quinacridone violet and burnt sienna skin mix is added wet-in-wet.

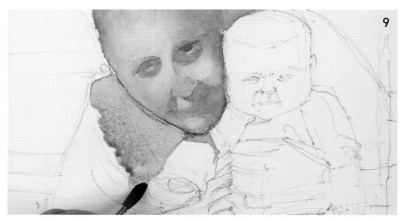

9 With the basics of the face in place, move on to the mother's clothing. Use the size 4 round brush to apply a flat wash of a grey mix – French ultramarine and burnt sienna – over the sleeve on the left of the painting. There are many folds here, but as long as the initial flat wash is light, these can be added later.

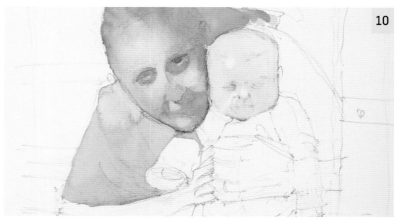

10 Make a very pale mix of quinacridone violet and French ultramarine and use the size 4 round to apply it to the baby's face. Working wet-in-wet, add a hint of very dilute viridian on the left-hand side, then lift out highlights on the forehead, cheek and nose using a little kitchen paper.

11 Add a hint of the quinacridone violet and French ultramarine mix on the ear and on the upper left side of the face; then let the baby's face dry. Once dry, use the size 4 round to begin to develop the modelling on the baby's face. Using the quinacridone violet and French ultramarine mix at a fairly dilute consistency, add in the shadow of the cheeks and the brow, softening the colour in.

12 Change to the size 0 round and add the darker shading using the dark mix of French ultramarine and burnt sienna. Add hints of quinacridone violet to the shading of the cheeks, to the lips, and to the nose. Preserve the light below the lip, where there is a little spittle.

13 Develop the modelling around the eyes using the size 0 round and the quinacridone violet and French ultramarine mix, then change to the size 4 round and shade the upper right-hand side of the face, dropping in a small amount of viridian lower down. Change to the size 0 round to continue to develop the lower part of the baby's face using the same mixes and colours.

14 Still using the size 0 brush, add the eyes using fine lines of the quinacridone violet and French ultramarine mix.

15 Make a strong dark mix of burnt sienna and French ultramarine. Using a dry size 4 brush, pick up the paint, and wipe off nearly all the paint. Draw the dry brush lightly over the baby's head to deposit touches of paint just on the raised texture of the paper surface, to represent hair. This process is called 'dry brushing'.

16 Blend the hair into the surface with shadow areas of dilute viridian and the French ultramarine and quinacridone violet mix, adding the paint to the surface using the 10mm (⅜in) flat brush.

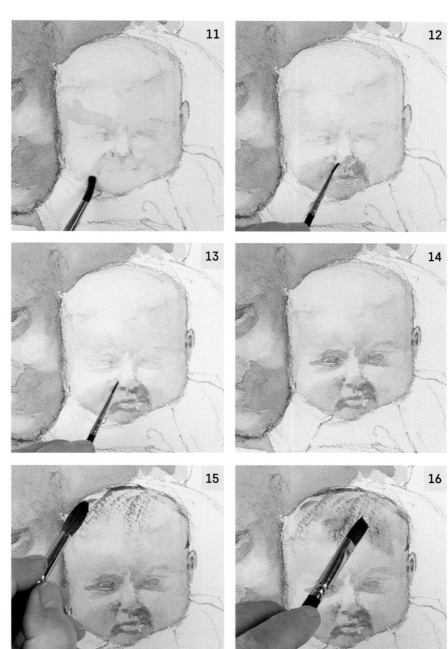

Refining the features

With the faces established, we now begin to refine them into likenesses with finer brushstrokes and the use of glazes. It is likely by this point that the colours in your palette will have become slightly intermixed, so treat the colours as guidelines rather than hard rules. Use the mixes on your palette to match the colour on your source photograph.

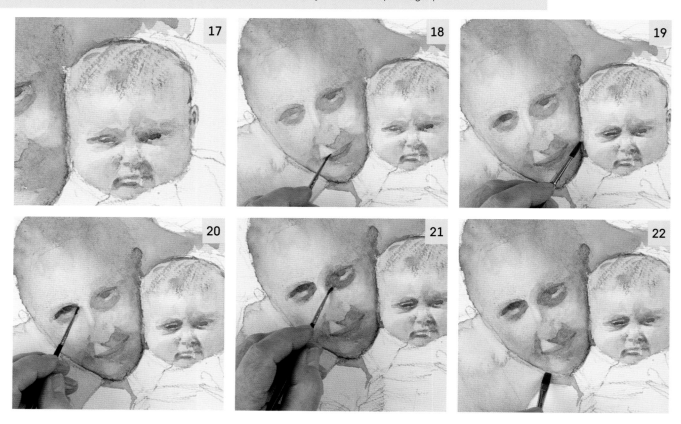

17 Strengthen the tone in the eyes and near the mouth using the strong dark mix (burnt sienna and French ultramarine), applying the paint with a size 0 round brush and quickly blending the colour in to develop the modelling on the baby's face.

18 Use the quinacridone violet and burnt sienna on your palette to make a mix for the lips, and apply the paint using the size 0 round. The slightest change in the line of the lip can gain – or lose – the likeness, so pay particular attention to the source photograph here.

19 Continue to develop and refine the two faces alongside each other with the colours and mixes described above. Shade the woman's eyes with a hint of dilute cerulean blue, and use touches of cadmium red alongside cerulean blue to add some rosiness and shadow to the baby's cheek. Use a size 4 brush to add

the dark area between the two faces. Use a mix of quinacridone violet and burnt sienna for a strong deep reddy-dark, and soften it in to the woman's face.

20 Using a combination of the mixes on your palette – a dark mix of French ultramarine and burnt sienna is a good analogue if you need to start from fresh paint – use the size 0 brush to develop the darkest tones in the eyes.

21 For softer areas, such as underneath the eyes, lay in small amount of colour, then rinse the size 0 brush and remove excess water. You can then use this damp brush to blend the colour in smoothly, avoiding harsh lines.

22 Strengthen and refine the features in shadow using the same mix and brush. Soften the colour in using a damp brush. If you need to make any corrections, lift out the colour using a 10mm (⅜in) flat brush.

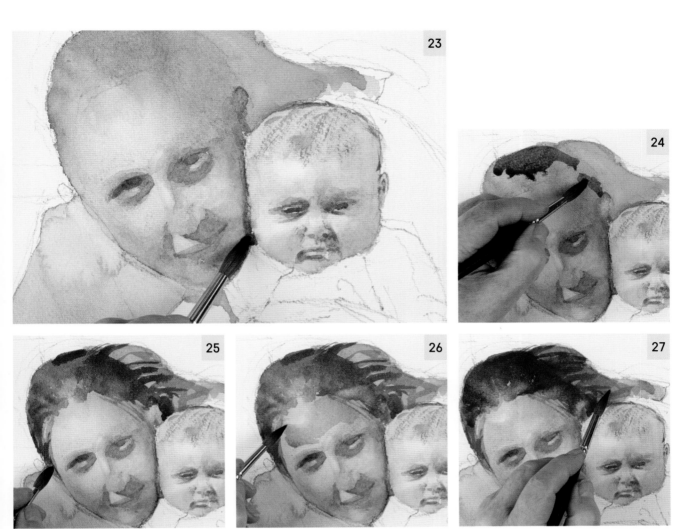

23 Use the size 8 round to lay in a very dilute glaze of cadmium red over the face of the baby. Keep this very dilute to give a very faint pink tinge to the underlying colours.

24 Lift out the mother's visible ear using the damp 10mm (⅜in) flat brush and a little kitchen paper. Change to the size 8 round brush and dampen the area in front of the hairline. Using a mix of burnt sienna and French ultramarine, begin to paint in the hair on the mother's head, using strokes that lead into the forehead as shown.

25 Add a few hints of the same mix to the ponytail, with strokes that lead towards the head, then add a hint of cerulean blue to the mix and develop the shadow areas towards the front of the head, letting the colours mix on the paper. Draw out some finer strands of hair on the right-hand side. Strengthen the burnt sienna and French ultramarine mix by adding a little more of the same paints, and use this to add shading and modelling to the hair.

26 Develop the hair a little more with some fine strands added with the point of the brush; and lifting out if necessary using the 10mm (⅜in) flat brush. Next, add a pinky tinge to the mother's forehead and ear using a dilute mix of quinacridone violet with a hint of French ultramarine, laying the colour on with the size 8 round.

27 Still using the size 8 round brush, strengthen the hair, being careful not to obscure the detail and modelling you added earlier. Use raw sienna to wash over the ponytail.

107

Adding impact and developing the background

Having developed the figures in this portrait, we now turn to presenting them in an attractive way and adding impact to the overall painting. Adding a strong background makes it easier to judge the tone as you continue working outwards from the faces.

28 Begin to establish the large dark indoors area around the figures. Use a dark mix of French ultramarine and burnt sienna, and apply the paint in smooth strokes of the size 8 round brush, working down from the top to the tops of the figures. While the paint remains wet, dilute the mix and paint in the woman's remaining sleeve and body. Work up to the background, allowing the colour to blend in naturally. Because the baby's sleeve and the mother's arm are dry, the colour will not bleed into these areas, and they will remain clean.

29 Build up the very dark tone of the room with glazes of the same mix, allowing each to dry completely before overlaying another. Rinse the brush before continuing.

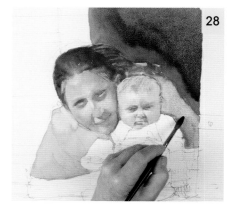
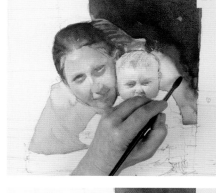

30 Add the baby's fingers with raw sienna, then paint the mother's arms using the skin mix (raw sienna, quinacridone violet and a touch of French ultramarine), adding more French ultramarine for shading. Paint the mother's hands using the 10mm (⅜in) flat brush so you can cut in sharp angles. Use the sharp corner of the flat brush to touch in some raw sienna and quinacridone violet for variety and the pinker skin of the mother's knuckles.

31 Add in the cast shadows around the ledge and in the baby's clothes, using a blue-grey mix of French ultramarine with a little burnt sienna. You can use a size 8 round for all of this, even the fine detail, as long as it comes to a good point. Work carefully around the shoelaces, leaving them as clean white paper. This technique is called 'negative painting'.

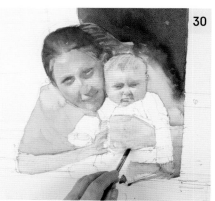
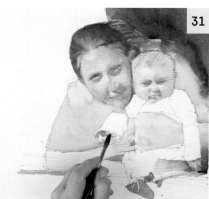

32 Use the same mix to add shadows between the fingers and on the hand, then add a hint of viridian to the mix, dilute it further, and add some soft shading under the arm.

33 Rinse the brush and use the damp bristles to soften the colour upwards into the arm to suggest the curvature. Next, use the viridian-tinged dark mix to scumble the brush over the ledge, creating a random texture.

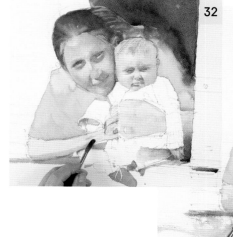
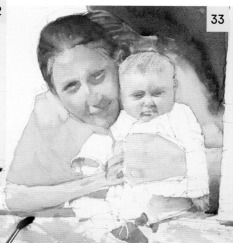

34 Still using the size 8 round, model the hands with the French ultramarine and burnt sienna mix before blending them in with some a raw sienna and quinacridone violet mix to lose any harsh edges.

35 Use the dark mix to add deep shading in the creases of the sleeves. Blend the colour into the surroundings with a clean damp brush.

36 Using a mix of quinacridone violet and French ultramarine, begin to develop the modelling on the baby's hands, in particular picking out the spaces between the fingers. Apply the paint with the size 0 brush, and pay careful attention to the reference photograph.

37 Re-establish the detail on the mother's hands using the 6B pencil. Hands are complex structures, so it is well worth the time spent to get the lines correct before you start painting. Use the mix of quinacridone violet and French ultramarine to create some basic structure on the hands with the size 0 brush, adding the dark tone in the space between the fingers and blending it up over the fingers to create the curved shape.

38 Use a very dilute mix of quinacridone violet with a hint of cerulean blue to strengthen the lips a little, applying the paint with the size 0 brush. Once dry, carefully draw a very fine line between the lips using the dark mix (burnt sienna and French ultramarine). Add more burnt sienna and use the ruddier dark mix to strengthen the tone in the shadows around the eyes.

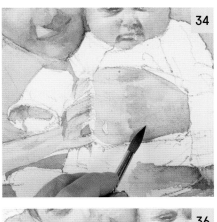
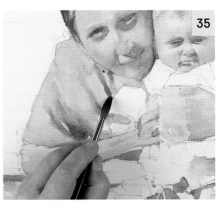
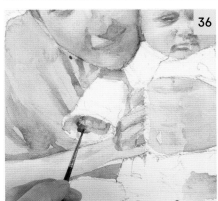
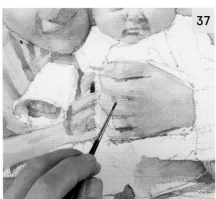
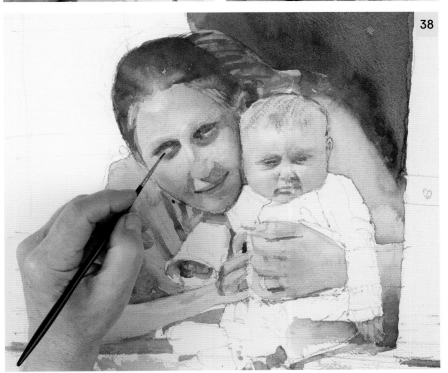

Finishing touches and tonal adjustment

With all the main elements in place, an assessment of the painting as a whole is timely at this stage. Any necessary tonal adjustments can be made, along with any additional details.

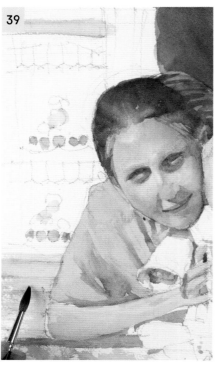

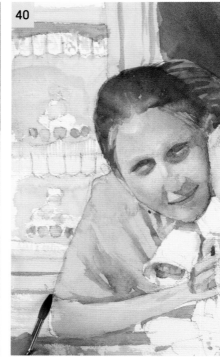

39 Use the 6B pencil to develop some detail on the lace curtain. Paint in the fruit decoration on the lace using raw sienna, cadmium yellow, and cadmium red. Apply the paint using the size 8 round. Use horizontal strokes of the brush to apply a dilute mix of perylene green to the window frame, then add some shading using the dark mix (French ultramarine and burnt sienna) at a dilute consistency.

Tip

Part of the reason for using the size 8 round is that it encourages you not to be obsessive about this minor part of the painting. Remember the focus is on the figures, so do not over-develop touches like the lace pattern.

40 Continue to develop the lace curtain and window frame using the dark mix at different consistencies. Flat washes are good for the larger areas, and you can create good lace effects using scumbling, dry brushing and fine lines.

41 Re-establish the baby's clothes using the 6B pencil, then use a mix of burnt sienna and French ultramarine to add some detail across the clothing. Use a size 0 brush for the very fine details, and change to a size 4 brush for the larger creases.

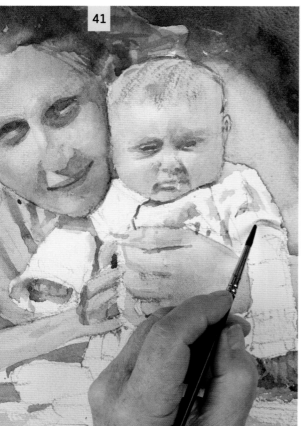

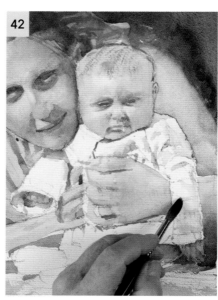

42 For softer shadows such as on the baby's forearm, use the brush to lay in clean water, dab away the excess, then begin painting. This encourages the colour to bleed in a little more, for a soft, diffuse result.

43 Develop the rest of the baby's clothing in the same way, moving from place to place and paying careful attention to the relationship between mother and child. Here, the small shadows caused by the mother's face on the baby's shoulder are important to help bind the two figures together.

44 Using the same dilute mix of burnt sienna and French ultramarine, add some stronger creases on the mother's t-shirt, then paint the shutter on the right-hand side with perylene green. Use the size 8 round and work quickly – a few gaps and spaces here help to give an impression of sunlight and freshness.

45 With all the parts of the painting in place, you can begin to evaluate the relative tones, and begin to make adjustments. These will depend on the particulars of your own painting. Here, for example, I have added a hint of very dilute perylene green under the mouth of the mother to slightly adjust the tone and bring the focus back to her face.

46 Add some details to the shutter on the right-hand side using the size 0 round brush and a mix of French ultramarine, burnt sienna and perylene green.

47 Using a size 4 brush, develop the shading on the baby's face. Use a mix of French ultramarine and burnt umber; stronger in the deeper shadows, and more dilute for softer areas. The right-hand side of the baby's face is catching a little reflected light from the shutter, so a hint of green will creep in – add a touch of viridian to the mix.

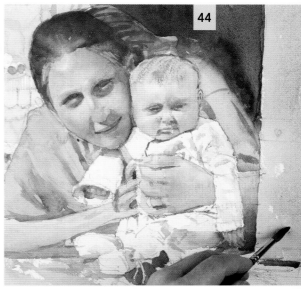
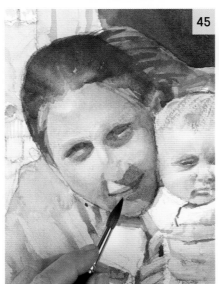
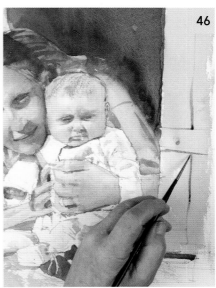
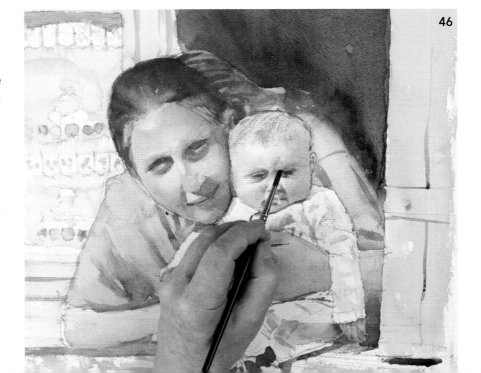

Overleaf:
The finished painting.

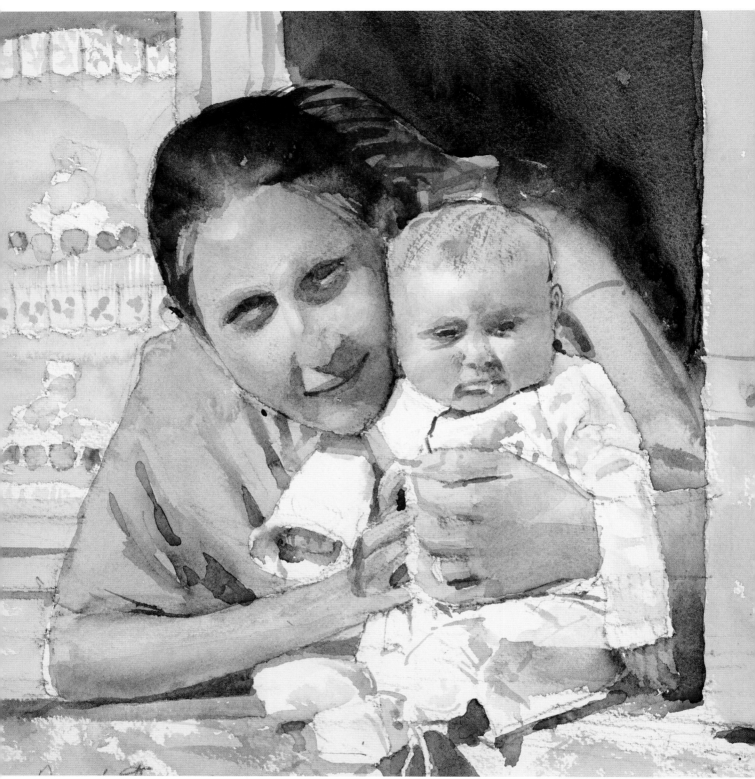

The finished painted portrait.

112

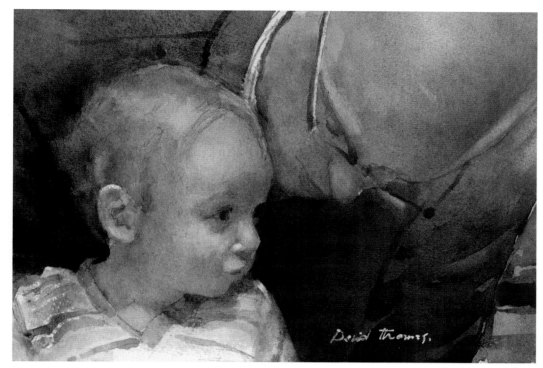

Father and Son

Fathers are important too! The skin tones were achieved by the application of several layers of glazing (see page 64), and in this respect is similar to the mother and child paintings. The colouring here is stronger, particularly in the father, but there is the same use of a dark background to throw out the main subject.

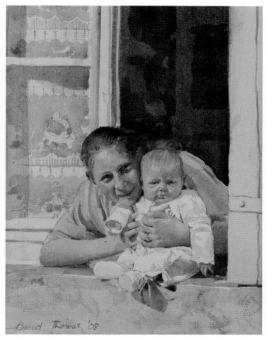

Mother and Child #2

This version of the portrait is the original; painted before the version shown opposite. I decided to adopt a square format for the demonstration in part because the large dark area in the original portrait format painting shown here was too much. I also thought the closer cropping used opposite concentrated attention on the two faces.

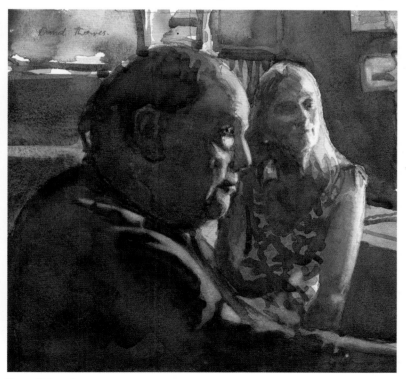

Two Friends

Another double portrait, this time of two friends, seen in the same pub featured in The Last Suppers (see pages 28–29). Sharing a similar format as the demonstration painting, the dramatic lighting offers an interesting variation that suits a painting of two adults.

Jilly
Close-up

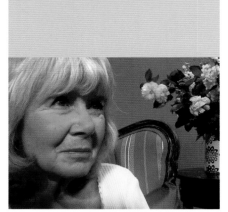

The source photograph used for this painting.

It is not often I have had the opportunity to paint a celebrity, and when it came it was in the form of a national portrait competition, for which various celebrities had made themselves available. For the following demonstration I have used a photograph taken at the time on my tablet. I had used this during the competition to give me a close-up of the eyes, but realised afterwards that it would have made a better basis for the main painting.

The intimate nature of this composition means that the top of the head is cropped off. It is important to remember this when you establish the eyeline, since it will not be halfway down as normal.

You will need

45 x 38cm (17¾ x 15in) 638gsm
 (300lb) Not watercolour paper

6B pencil

Masking tape

Plastic eraser

Water pot

Kitchen paper

Brushes: size 0 round sable, size 8
 round sable, size 4 round, 5mm
 (¼in) flat brush, 25mm (1in)
 hake, size 2 rigger

Colours: raw sienna, burnt sienna,
 French ultramarine, viridian,
 perylene green, cerulean blue,
 quinacridone violet, cadmium red,
 cobalt blue, cadmium yellow

White ink

Household sponge

Basic lines

Use sticky tape to secure your paper to the board. Use a 6B pencil to draw a loose rectangular frame to establish the edges of the composition. Draw a large oval for the head, making sure it extends beyond the frame, and with the right-hand side sitting roughly in the middle of the frame.

Draw in horizontal lines to demarcate the mouth and nose, then establish and refine the features. Do not work one feature to completion before moving on to the next – instead, work lightly and refer to other features to ensure the whole piece works together.

As always, be prepared to take as long as it takes to get

an accurate drawing. When adding hair, look for edges, gaps and other reference points to get the shape of the general mass of the hair. With the head itself in place, add the chair and vase of flowers with a couple of loose lines. Keep them fairly abstract – you just need the general impression of the flowers, not botanical accuracy.

Finally, check the drawing for accuracy, and make any adjustments using an eraser and the 6B pencil before continuing. Pay particular attention to the subtleties in the features – the arch of the nostrils, the line of the neck and form of the lips, for example.

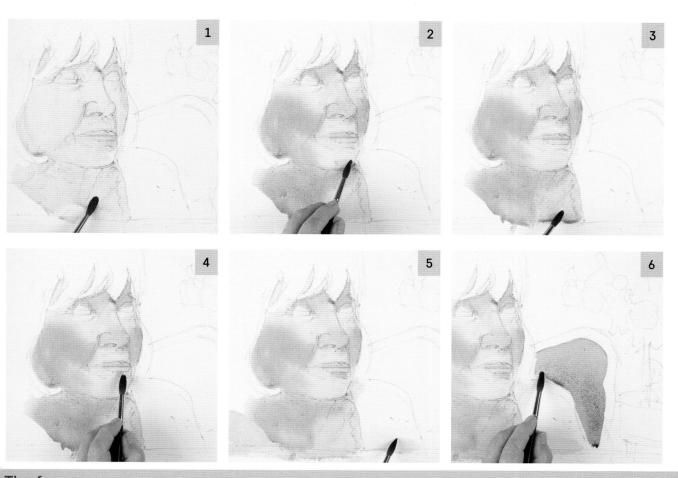

The face

As with the earlier projects, the face is built up first using the wash and wet-into-wet techniques. The warmer indoor light is suggested through the use of warm skin colours based around raw sienna.

1 Prepare two mixes: the first of raw sienna with just a touch of burnt sienna, and a slightly darker one made up of raw sienna, burnt sienna and touches of French ultramarine and cadmium red. Using a size 8 round brush, use the first mix to lay a flat wash over the whole skin area, starting from just under the hair and working down over the neck. Work right over the eyes.

2 Use the darker mix to add a ruddier touch to the cheek, using the brush stroke to suggest the curve of the cheek. While the paint remains wet, use the same brush and mix to add some initial shading and colour to the brow, nose, neck and lips. Use the end of the brush for finer areas like the lips.

3 Add a little viridian to the mix and paint in the cooler shadow on the chest.

4 Make a grey mix of burnt sienna and French ultramarine and add a hint of shadow under the lower lip.

5 Paint her top with a dilute mix of French ultramarine and viridian, leaving some white areas on the left-hand side of the picture.

6 Still using the size 8 brush, use the grey mix (French ultramarine and burnt sienna) to paint in the cushion of the chair. This darker tone will help to throw the figure forward, particularly when next to the high contrast white areas of the cardigan.

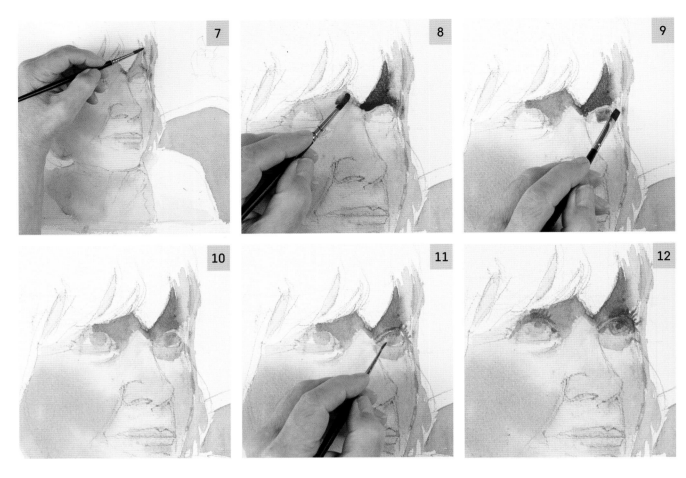

7 Use the dilute viridian and French ultramarine mix to begin to paint in the shadows of the hair. Use shorter, more controlled strokes to suggest the way the hair hangs. Change to the size 4 brush now for more control. Add perylene green to the raw sienna and burnt sienna mix and begin to paint in the hair on the right-hand side. Use the mix fairly dilute and blend it in alongside the viridian and French ultramarine shadows.

8 Still using the size 4 round brush, use the dark mix (raw sienna and burnt sienna with touches of French ultramarine and cadmium red) to paint in the heavy shadows under the hair, blending the colour away for slightly lighter areas.

9 Using the same perylene green, raw sienna and burnt sienna mix, paint in the iris of the right-hand eye with the size 4 round, then change to a damp 5mm (¼in) flat brush to lift out a little paint just to the right of the eye.

10 Apply a dilute mix of cerulean blue and quinacridone violet under the eye, then add a hint of cadmium red in the corner of the eye. Paint the other eye in the same way, using slightly more dilute mixes and smaller areas of shadow to show this eye is less overshadowed by the hair.

11 Allow the area to dry completely before continuing. Change to the size 0 round and use a strong version of the perylene green, raw sienna and burnt sienna mix to paint in the eyelashes, extending them into the area that you lifted out earlier. Ensure you keep the lines fine – you should still be able to see the skin of the eyelid itself.

12 Add stronger hints of cadmium red in the corners, then paint in the pupils using a mix of all four paints – perylene green, raw sienna, burnt sienna and cadmium red. Allow the eye to dry completely, then use the rigger and the same mix to add modelling to the iris itself. Refine the eye with the same mixes until you are happy, then paint the other eye in the same way.

13 Change to the size 4 round and use a darker mix of French ultramarine and burnt sienna to paint in the nostril. Use a slightly more dilute mix to paint in the shadow of the nose on the cheek and blend it away a little.

14 Use a damp 5mm (¼in) brush to lift out a little colour between the lip and nose and add a hint of perylene green here, joining the nose to the shadow.

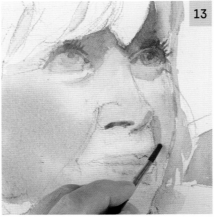
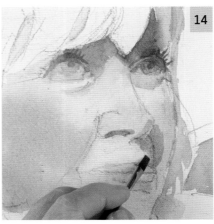

15 Add some modelling to the top part of the nose using a dilute mix of raw sienna, burnt sienna and French ultramarine, then add a hint of cadmium red to add some colour and form. Use the grey mix (burnt sienna and French ultramarine) to add some shadows to the nose.

16 Add a little quinacridone violet to the grey mix and paint in the lips, leaving a small gap between them and preserving the little point of highlight on the left-hand side. Draw a fine line down the line of the cheeks, rinse the brush quickly, remove excess water, and draw the damp brush down to blend the lines into the cheeks.

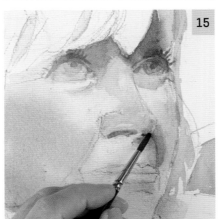
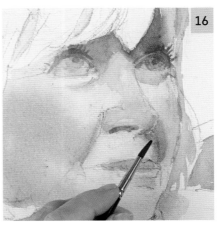

17 Change to the size 8 round. Lay in a strong red mix of cadmium red and burnt sienna on the neck, leaving spaces for highlights, then drop in French ultramarine to add deeper shadows. Allow the colours to blend, and apply touches of the red mix (cadmium red and burnt sienna) and French ultramarine where necessary to suggest the shape of the neck.

18 Extend the French ultramarine shadow over the arm on the left-hand side. Use a damp brush to blend the colour over the chin to add soft modelling, then use the dark mix (French ultramarine and burnt sienna) to add shadows under the hair on the left and in the deep recess of the neck and shoulder. Draw the colour down over the cardigan, then let the painting dry completely.

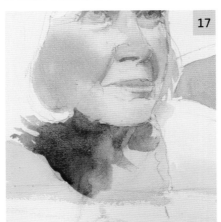
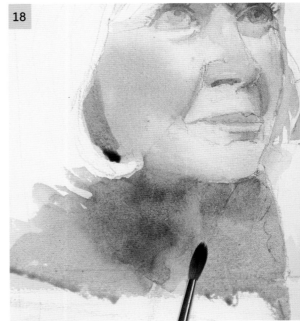

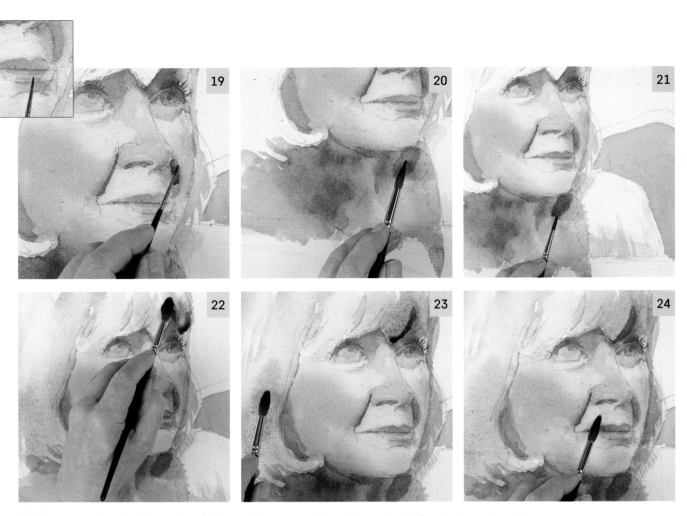

19 Change to the size 0 round and draw a fine strong line of the red mix (cadmium red and burnt sienna) across the mouth (see inset). Draw the colour up to add some small marks to show wrinkles on the lips, then dilute the mix and add some more colour to the lower lip. Using a deep tone of the grey mix (French ultramarine and burnt sienna), add a strong line of shadow on the cheek. Soften it in at the lower end, drawing the colour out to add modelling at the corners of the mouth. Do the same on the right-hand side, broadening the stroke as you soften it.

20 Using the cadmium red and burnt sienna mix and the size 4 brush, reinstate the line of the jaw. Drop in a little French ultramarine to develop the shading on the jawline, and use all three colours together to strengthen the shadow in the neck.

21 Change to the size 4 round brush and use the grey mix at different dilutions to add some fine stripes and shading on the cardigan. Do not draw the lines straight across the top. Instead, work only over the parts in shadow, and take the lines up to, but not over, the white highlight area. Reinforce the shadows below the chin and under the hair using the grey mix, applying the paint with the size 4 round.

22 Dampen the whole area of the hair using clean water and the size 8 brush, then quickly wipe over the hair with kitchen paper to take off the excess. Using the size 8 brush and the grey mix, use large strokes to quickly cover the area, leaving some spaces for highlights.

23 While the paint remains wet, add hints of cadmium red to the grey mix (French ultramarine and burnt sienna) and add some warmth to the hair on the top left. Add more French ultramarine and start to deepen the shadows with a cool layer over the top – particularly on the right-hand side and at the bottom of the hair.

24 Use the size 8 brush to add a very dilute glaze of quinacridone violet over the whole face with the exception of the cheek on the right-hand side.

Background and refinements

With the face established, it is time to add the background elements. Adding the chair and table allows the painting to be considered as a whole. If such elements were to be left to the end, an imbalance might occur, requiring alterations to the face. Developing the background at the same time as the face avoids this potential problem.

25 Use the grey mix to paint the edge of the chair. Use the size 4 round brush to make it easier for you to leave some fine white lines showing. Introduce variation to the area by changing the intensity of the mix, as well as the proportions of French ultramarine and burnt sienna in it.

26 Paint the side table in the same way. Since there is less visible detail here, you can change to the size 8 brush. Make sure the top is distinct from the rest of the table by using more burnt sienna for this part.

27 Hint at the seam of the cushion on the chair using the same mix, applying the paint with the size 0 round brush.

28 Using the size 8 round brush and French ultramarine, knock back the neck area, and extend the colour up into the hair with fine quick strokes. Change to the size 4 and introduce a hint of viridian wet-in-wet for detail and to cool the area.

29 Still using the size 4 round, continue to develop the skin texture across the face and neck with dilute layers of burnt sienna, varying the hue and tone with touches of French ultramarine added wet-in-wet.

30 Use very dilute French ultramarine to add a shadow on the upper lip, softening it away almost to nothing with clean water. Add quinacridone violet to do the same on the nostril, extending it into the cheek.

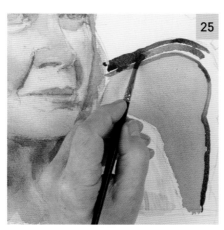

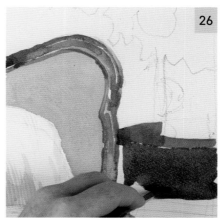

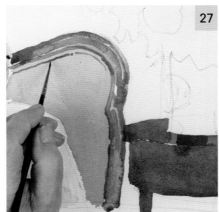

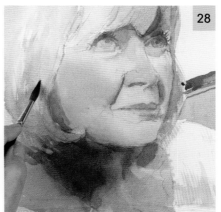

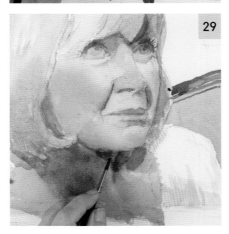

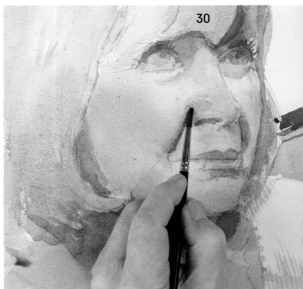

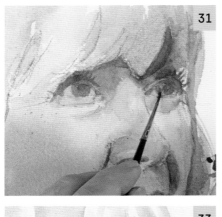

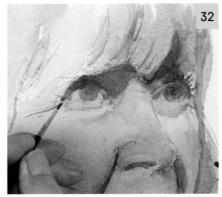

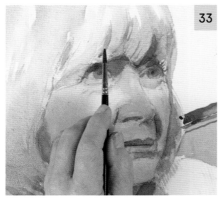

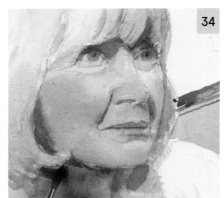

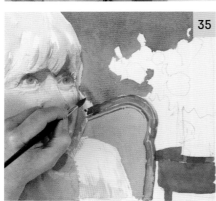

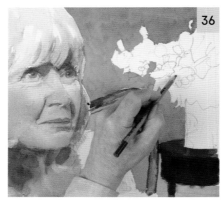

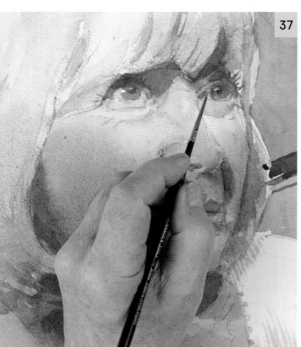

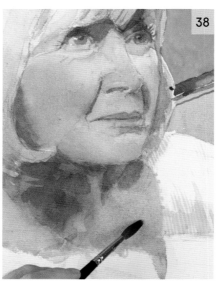

31 Combine cobalt blue with viridian. Use the size 0 round brush to add detail to the eyes.

32 Change to the size 4 round, and reinstate the shading under the fringe of hair with a mix of quinacridone violet and burnt sienna. Draw shadows up into the hair with quick strokes of the brush. Change to the size 0 round and use the same mix to add the slight crease across the top of her nose and some of the fine lines around the eyes.

33 Mix quinacridone violet with raw sienna and use the size 4 round to apply it to the left-hand side of the lips and the shaded skin visible through the fringe.

34 Change to the size 8 round and add a stroke of dilute raw sienna across the cheek. Work downwards to the bottom of the chin, adding touches of quinacridone violet wet-in-wet to strengthen and reinforce the colour in the lower part of the face.

35 Lay a wash over the background with the size 8 brush and a terracotta mix of cadmium red, raw sienna, quinacridone violet and French ultramarine. Use negative painting to work round the flower outlines, leaving the flower and pot as clean paper, but work right over the table. This layer will soften as it dries, leaving a little of the colour to give the impression the background wall is reflected in the glossy surface of the table.

36 Once dry, use the 6B pencil to add more detail to the flowers.

37 Add tiny touches of white ink to the eyes as bright reflected highlights, applying the ink with the point of the size 0 brush. Dirty the ink a little by mixing it with the colours on your palette to add the slightly duller highlight on the right-hand eye.

38 Use the size 8 brush to lay in a light wash of raw sienna and quinacridone violet over the chest.

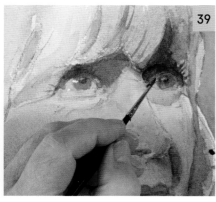

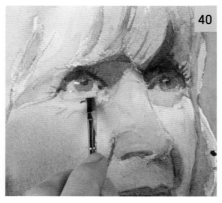

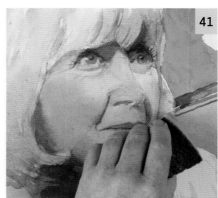

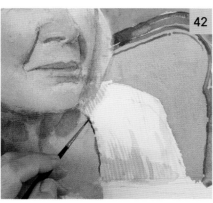

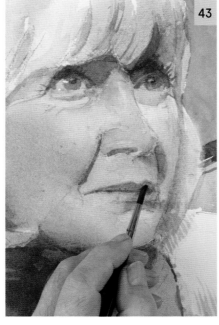

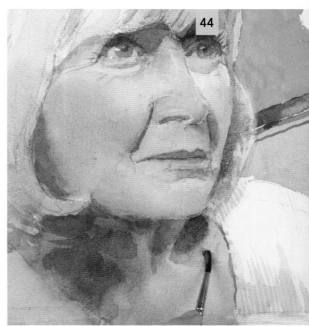

39 Change to the size 4 brush and begin to strengthen the tones around the right eye using perylene green over the deep shadows and eyelash area. Change to the size 0 brush to add the shadow of the eyelid over the eye itself.

40 On the left-hand eye, use a mix of quinacridone violet with a little cadmium red to add warm shadows around the top of the eye, then add a hint of French ultramarine into the shadow below the eye. Soften the colour in using the 5mm (¼in) flat brush.

41 Change to the size 0 round brush and add French ultramarine to the quinacridone violet and cadmium red mix. Use this violet hue to add some shadows cast by the hair onto the skin. If you have any hard edges in the hair at this point, use a damp sponge to rub at the area to soften them. Allow the painting to dry before continuing.

42 Use the grey mix (French ultramarine and burnt sienna) to develop a harder shadow between the cardigan and the skin.

43 Change to the size 4 round. Further refine the skin around the nose and eyes using dilute glazes of quinacridone violet with a little cadmium red, and use a similar but stronger mix for the lips.

44 Still using the size 4 round, add perylene green to reinstate the shadow on the hair on the right-hand side. Start right next to the skin, then draw the colour across the hair with the brush. Extend the colour down over the recesses on the neck, then change to a warmer mix of burnt sienna and quinacridone violet to warm the shadow on the jaw.

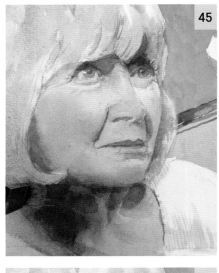

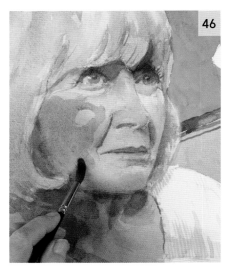

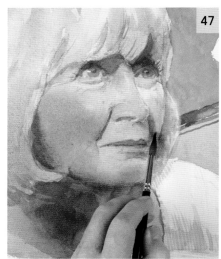

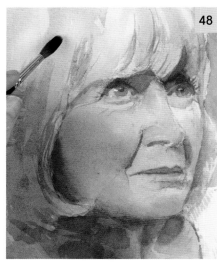

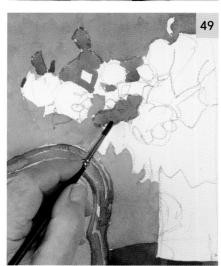

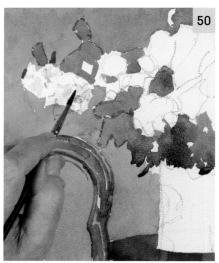

45 Make a green-grey well with burnt sienna, French ultramarine and perylene green. Use a 25mm (1in) hake brush to apply a glaze of the colour over the hair.

46 Use the size 8 round brush to add a glaze of dilute French ultramarine over the cheek, leaving a small highlight gap. Soften it in using clean water at the edges.

47 Add quinacridone violet wet-in-wet, reserving the colour for the apple of the cheek; then repeat the process on the left-hand cheek. Allow the painting to dry completely.

48 Use the size 2 rigger to add fine lines to the hair using the grey mix (French ultramarine and burnt sienna), then change to the size 8 round to add larger areas of the same mix, particularly at the top left-hand corner of the picture.

49 Mix viridian, cadmium yellow and raw sienna and use the size 4 round to begin painting the leaves and foliage of the plants in the pot. Leave a few hard edges and use negative painting to create spaces.

50 Use a quinacridone violet and French ultramarine mix to paint in some of the flowers, simply adding shading by dropping in hints of pure French ultramarine.

51 Still using the size 4 round, add raw sienna to the grey mix (French ultramarine and burnt sienna) and use this to add the suggestion of texture and other modelling on the white flowers. Add hints of pure raw sienna in the centres of one or two. Once dry, use the 6B pencil to further develop the pattern on the pot.

52 Paint the pattern using the size 4 brush and French ultramarine. Add a hint of burnt sienna to stop the hue from being too vibrant and eye-catching. Use the same colour to add the suggestion of the pattern in the reflection on the table.

53 Once dry, lightly wash over the pot using a size 8 brush and the grey mix (French ultramarine and burnt sienna).

54 At this point, step back and evaluate your painting. Here, the shadow of the hair needs to extend more over the left-hand side of the face, so I used a damp sponge to lift out the area and re-established the shadow once it was dry, using the mixes listed above.

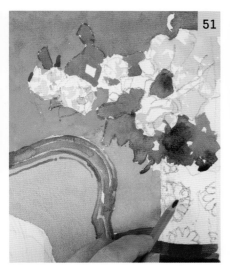
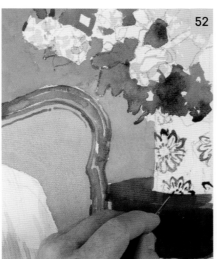
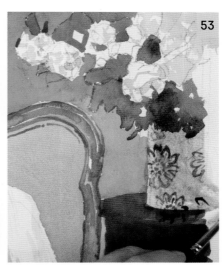

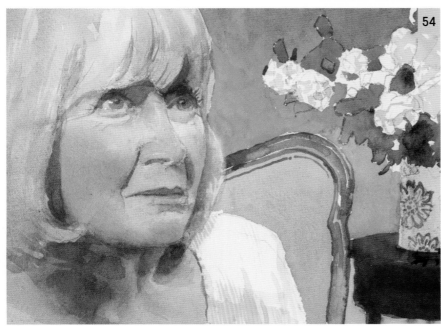

Overleaf:
The finished painting.

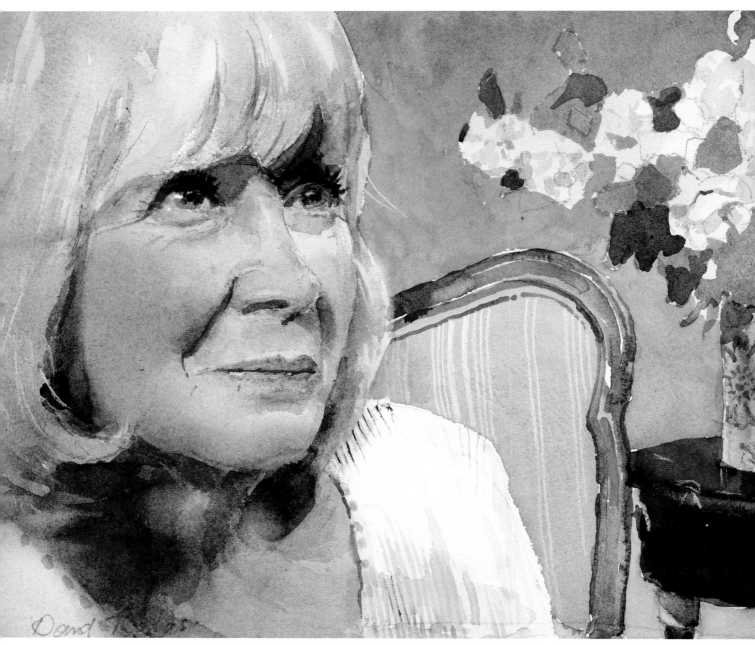

The finished painted portrait.

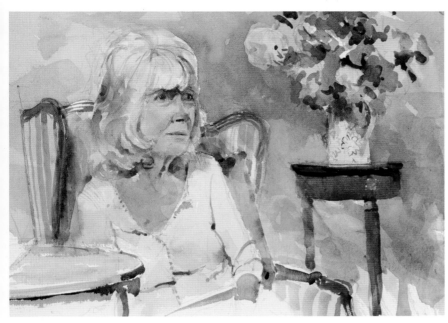

Jilly #2

This version was painted from life in four hours. It has the faults and virtues of the process, as will any painting, portrait or landscape, painted directly from the subject. In this case, the area to the bottom left is unfinished, and the drawing of the wings of the chair is faulty. The composition probably is too divided between Jilly and her flowers.

Compare this original version with the one shown opposite – note that the closer cropping makes that more of a portrait than a painting. In particular, I was able to pay more attention to the eyes in the version on page 124.

Bob

There is no immediate similarity, in subject or treatment, between Jilly and Bob, except that they were both produced under pressure and the presence of a camera. Although Bob was briefly present in my living room at the start and end of the process, I relied on a photograph which I had taken earlier, which was projected onto a television screen – my usual method. As with Jilly, I made a freehand pencil drawing, adjusting and correcting until I felt I had a likeness.

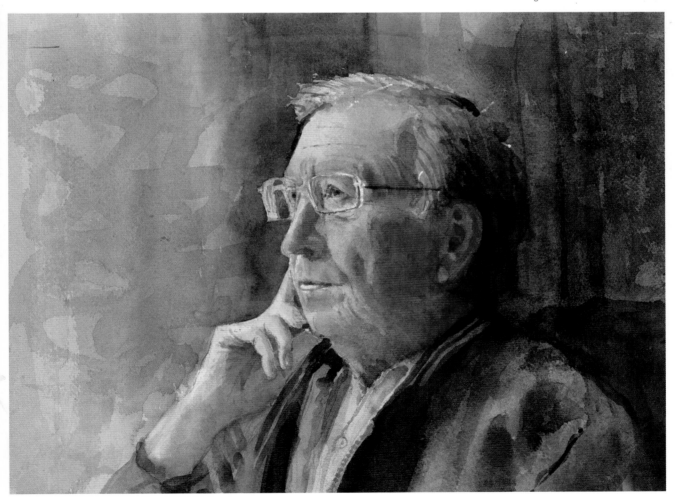

Afterword

The drawings and paintings in this book are traditional, in that they are the result of direct observation, place an importance on sound drawing and employ aesthetic judgements about composition, colour and tone. These have been the concerns of painters for centuries, and although various challenging movements have arisen during that time, the art world has always returned to such core values. Applying them has resulted in some of the greatest works of art ever made and, since portraiture is ranked high in the painting hierarchy, it follows that some of these great paintings are portraits.

It may not be your ambition to attain such distinction, but if you are diligent and willing to learn you will find your way to an authentic and personal style. Portraits are often handed down from generation to generation and this, in a way, invests them with a form of greatness.

Waiting for the Telegram

Katherine was approaching her hundredth birthday when I had occasion to visit my friend, with whom this lady lives. It was my first meeting with her, and I was struck by her cheerful personality, and also by the extraordinary light on her face.

Being Belgian, when the telegram came, it was from Iain Macleod rather than Queen Elizabeth II, as British readers might expect. However, being Catholic, she also got another from the Pope!

This painting was exhibited at the Royal Birmingham Society of Artists' portrait exhibition 2015, and received the Clairefontaine award.